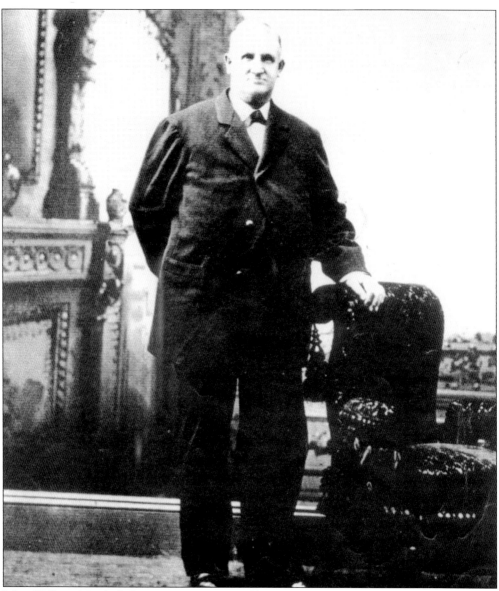

John William Mitchell, born June 1828, Woodbury, Connecticut, and died November 1893, Turlock, California, was the founder of Turlock. He granted the right of way to the Southern Pacific to extend the tracks south and negotiated for a depot to be built. Before the depot was completed, the name Turlock was registered in Washington for a post office. The railroad offered to call the depot Mitchell Station, but John Mitchell declined the tribute, asking that the name be the same as the post office: Turlock. These events in 1871 signaled the birth of a town. The man that brought the railroad and established Turlock would later be an ardent supporter of irrigation. His prediction was that water would bring new opportunities in crops and continued prosperity, "with a new brick building on every corner." (Courtesy Robert Brown Collection.)

Kristen Santos and Phyllis Soderstrom
Thea Sonntag Harris and Monica Harris

Copyright © 2003 by Kristen Santos and Phyllis Soderstrom, Thea Sonntag Harris and Monica Harris.
ISBN 0-7385-2092-6

First Printed 2003.
Reprinted 2004.

Published by Arcadia Publishing,
an imprint of Tempus Publishing, Inc.
Charleston SC, Chicago, Portsmouth NH,
San Francisco

Printed in Great Britain.

Library of Congress Catalog Card Number: 2003101678

For all general information contact Arcadia Publishing at:
Telephone 843-853-2070
Fax 843-853-0044
E-Mail sales@arcadiapublishing.com
For customer service and orders:
Toll-Free 1-888-313-2665

Visit us on the internet at http://www.arcadiapublishing.com

This book is dedicated to Robert Brown, a Turlock historian, who has spent a large portion of his retirement years diligently scanning, cross-referencing, and documenting early photos, written accounts, maps, and other resource materials to archive accurate information about Turlock's history for future generations.

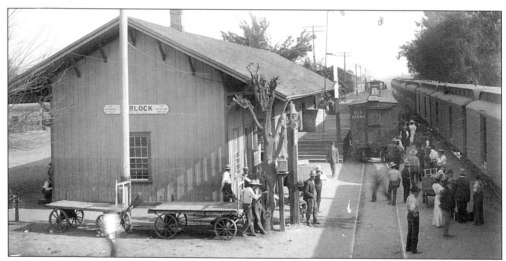

The coming of the iron horse and the construction of a depot signaled to business proprietors that the newly formed area, called Turlock, could be a successful town. The businessmen moved buildings to town and built new ones to provide goods and services to farmers and anyone getting on and off the train. The railroad, with its depot, was one important factor that brought Turlock alive and kept it growing and changing through the end of the 19th century. (Courtesy Mike Ertmoed Collection.)

Contents

Acknowledgments — 6

Introduction — 7

1. Cultivation of the Valley — 9
2. The Iron Horse — 15
3. Immigration and the Family Farm — 29
4. The Wedding of the Land and the Water — 43
5. Incorporation: A New Beginning — 59
6. The Time between the Wars — 83
7. Uniting for Victory — 103
8. City of Churches — 117

Acknowledgments

We extend our gratitude to the following individuals and organizations that have supported us in this project. We thank them for their willingness to share their photographs, their memories, knowledge, and generously given time without hesitation or question.

Organizations and their representatives: California Department of Transportation, California State University Stanislaus (University Archives), Emanuel Medical Center, Thirty-eighth District Agricultural Association, Stanislaus County Library (Turlock Branch), Turlock Chamber of Commerce, Turlock City Arts Commission, Turlock Fire Department, Turlock High School, Turlock Historical Society, Turlock Irrigation District, and *Turlock Journal*.

We extend credit and acknowledgment to Turlock Irrigation District for supplying technical information and text necessary for captions in "The Wedding of Land and Water" chapter.

Private collectors: Abraham family, Scott Atherton, Robert Brown, Ray Conyers, Ailene Cross, Jack Doo, Mike Ertmoed, Beatrice Hapgood, Jim and Gert Hughes, Ivan Lowe, Edna McMurphy, Gordon L. Petersen, Esther Noda Toyoda, and Marlene Wilson.

We would like to acknowledge the accomplishments of Helen A. Hohenthal and John E. Caswell, with the book, *Streams in a Thirsty Land*. This detailed history of Turlock is the starting point for any research on the town's history. It has served as a necessary resource and helpful guide during this project.

We are deeply grateful and extend special thanks to three local Turlock historians who have provided valuable insight, suggestions, and corrections, and who demonstrated their patience when taking our calls and answering our questions. They are Scott Atherton, Mike Ertmoed, and Robert Brown.

Introduction

The Great Valley of California is divided into the northern portion, the Sacramento Valley, and the southern portion, the San Joaquin Valley. The dividing point is the Delta where river waters join and flow to the sea through San Francisco Bay. The land that would become Turlock is located in the southern portion of the San Joaquin Valley near the Tuolumne River in Stanislaus County. Those who have studied the valley say that the area was naturally designed for agriculture with snow accumulation to the east in the Sierra Nevada range, a relatively flat valley floor, and an abundance of sunshine. In *The Seven States of California*, author Philip L. Fradkin contends that the valley's natural landscape has been superficially altered by man four times in the last 200 years. The first alteration occurred around 1800 when the natural landscape was changed to a livestock or grazing landscape. In 1865 the grazing landscape was converted to a wheat production landscape. The change from a wheat, dry-farming landscape to an irrigated, agricultural landscape began to occur around 1900. Finally around 1960 the agricultural landscape began to coexist with the urban landscape.

The Native Americans, the Yokut Indians, are known to have lived in the valley during the natural landscape period. One historian refers to the Yokuts of Stanislaus County as Laquisimas Yokuts, who called the Stanislaus River Laquismes. They were associated with tribes or "ocean people" from the coast and their currency or coveted treasures were forms of abalone jewelry or pieces of abalone shell. Some historians contend that the Yokuts, who ate mostly seeds, plants, edible roots, and some fish, were driven from the area during the 1850s when the change to livestock grazing peaked. Other sources indicate that the Yokuts had migrated from the area before the grazing of large herds began.

One settler in the valley, John William Mitchell, participated in both the livestock period and the conversion to the wheat, dry-farming period. Mitchell enjoyed financial success buying land, developed large herds of cattle and sheep, and marketed them to the gold country miners. He purchased additional lands, over 100,000 acres in total, and became a wheat farming leader, cultivating tracts under the tenant system. During this time, Mitchell observed that transportation dependency was beginning to shift from the river to the rail. He had the vision to match his land purchases to the speculated route of the Southern Pacific expansion to the south.

John Mitchell granted the right of way to the Southern Pacific and negotiated for a depot in what would become Turlock. This transportation link for freight and passengers was the catalyst that brought business proprietors and settlers to the area and changed the 1850s settlement into an organized town. The founder of Turlock, John Mitchell, had no children,

but some of his siblings and their descendants did follow him to this new town. Many Turlock residents today find their roots in the extended family tree of John Mitchell.

While the depot was being constructed, Mitchell built a grain warehouse. Businessmen moved buildings to town or built new ones to provide goods and services to farmers and anyone getting on or off the train. The railroad, with its depot, was one important factor that brought Turlock alive and kept it growing and changing through the end of the 19th century.

At the turn of the 20th century the Turlock Irrigation District, the first California district under the Wright Act of 1887, brought irrigation water to the valley. As the irrigation system was being developed, wheat production was declining. Heavy grain production was exhausting the once-fertile soil and new crops with irrigation could mean renewed success. The Turlock Irrigation District was the second important factor that has kept Turlock thriving, growing, and changing through the end of the 20th century.

Around 1893, the landholdings of the deceased John Mitchell were being subdivided into 20 to 40 acre tracts. A large influx of new settlers from the mid-west arrived in Turlock in 1903 and 1904 because of the milder climate, cheap land prices, and the promise of abundant irrigation water. A dam and system of canals provided the necessary resource for crop diversification and the development of agricultural industry that changed the small town into a successful city.

We have selected photographs that chronicle the changes to the land and the evolution of an 1850s settlement into an organized town of 1871, then into an incorporated city of 1908, and finally the diverse community that emerged in the first half of the 20th century. We have tried to share many of the names and faces of the people of Turlock whose cultures and values shaped the community. In every decade, their sense of determination and perseverance is an untarnished example of the American spirit.

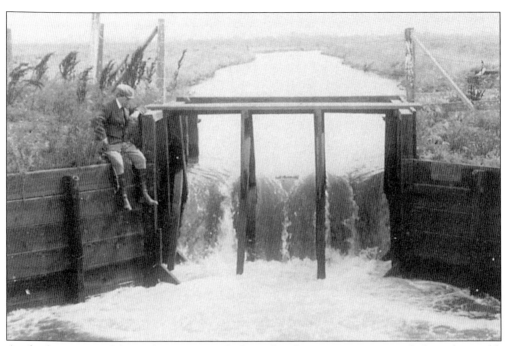

At the beginning of the 20th century, with the railroad as its transportation link to the world, Turlock's irrigation system was developed. This was the second important factor that kept Turlock growing and changing. For one hundred years, irrigation has been largely responsible for the economic, social, and demographic evolution of the area. (Courtesy Turlock Irrigation District.)

One
CULTIVATION OF THE VALLEY

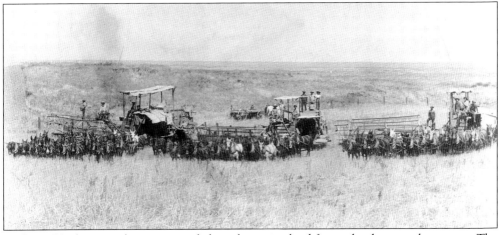

In the 1850s the natural prairie provided ample grazing land for cattle, sheep, and mustangs. The large population in the gold country increased the demand for food supplies and livestock. The valley settlers responded to that demand. Cattle and sheep were fattened up for market, and mustangs were rounded up and sold to the miners. Early settlers located along the banks of the Tuolumne and San Joaquin Rivers to be close to the cheapest and quickest means of transportation. In the next decade livestock epidemics and over-grazing made the valley settlers look to the plow for their success. Settlers around Paradise City were having positive results grain farming. These crops pushed southward as farmers increased their acre holdings. New settlers from the mines sought their own lands and a conventional method for success. By 1870 most of the area that would later become Turlock was under cultivation. (Courtesy Turlock Historical Society.)

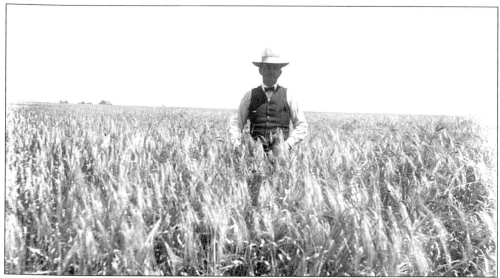

Wheat was the number one crop in the area. However, some fields of barley, rye, and other hay were grown. During years of adequate rainfall, farmers did so well that by 1872 five million bushels of wheat were produced in the county. Farmers were winning the battle against locusts, birds, rabbits, and drought, and every successful crop provided a means to increase their holdings. (Courtesy University Archives CSU Stanislaus.)

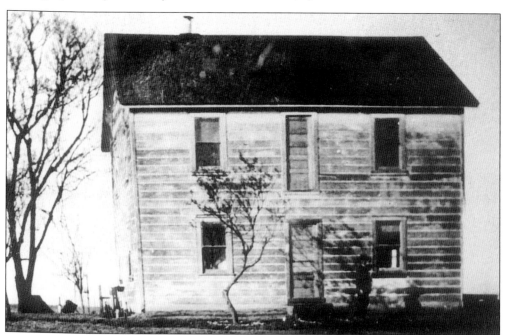

By 1870 it was common for prosperous farms to be 5,000 to 10,000 acres, sometimes more. Most federal land had been acquired by the large land holders and the labor force was provided through the tenant system. This tenant house, near Delhi, is an example of the many built in the area. Landowners received a percentage of the crop in exchange for a house, seed, and sometimes a team. When lumber was in short supply or the number of tenants exceeded available houses, one family would move in upstairs, the other downstairs. (Courtesy Robert Brown Collection.)

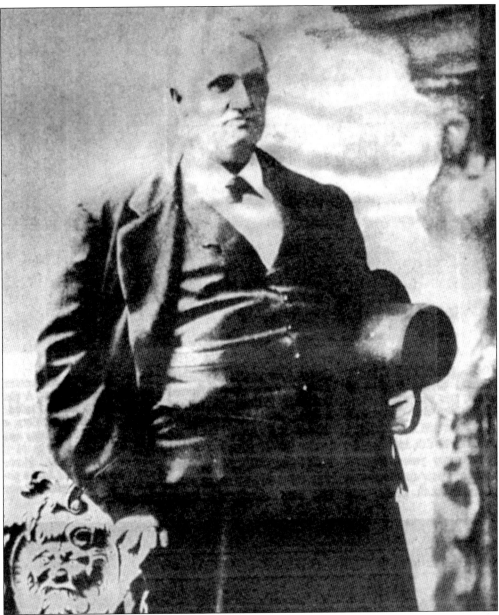

John Mitchell, founder of Turlock, came west from Connecticut in 1851. In San Francisco he and his brother worked as carpenters to raise enough money for scythes and swaths. With those tools, they made enough money cutting hay near Stockton to go into the transport business between Stockton and the gold mines. With money from that venture Mitchell began buying land around Paradise City and building up herds of cattle and sheep. By 1868 Mitchell had 17,000 acres under wheat cultivation and was again successful. Profits from tenant wheat farming allowed Mitchell to buy government land at $1.25 per acre. Overall he purchased 100,000 acres from the Keyes Switch to Atwater. Mitchell had the vision to match his land purchases to the speculated route of the Southern Pacific expansion to the south. He was correct in speculating that transportation dependency would be transferred from the river to the rail. At the time of his death, Mitchell's fortune was estimated at $3,000,000. (Courtesy Turlock Irrigation District.)

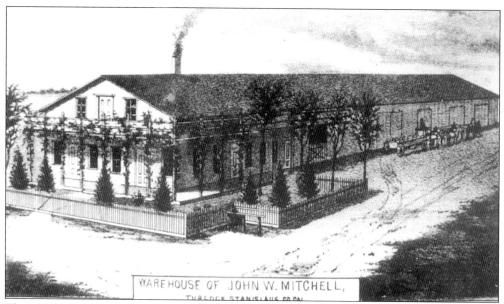

The Mitchell grain warehouse was constructed while the railroad depot was being built. It was located at Front and Olive Streets in Turlock. Grain storage in Turlock and transportation to market by rail would save time and money. Hauling grain to the Tuolumne River or making the long haul by wagon to Stockton had previously been the only routes to market. Mitchell never built a home but had modest living quarters at the end of each warehouse. He traveled by buggy to his various holding sites, kept most of his business records in his head, and his word was considered his bond. (Courtesy Robert Brown Collection.)

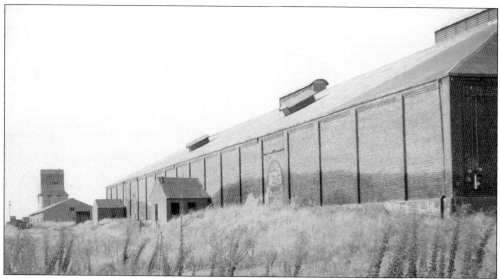

More people were settling in the area and becoming tenant wheat farmers. The number of acres under wheat cultivation increased and in years of good rainfall, production volumes rose. Grain warehouses became larger and more numerous. The use of warehouses provided a marketing advantage to the farmers. All the grain did not have to be shipped when harvested. Product could be held back for sale at a later date when supply was lower and prices higher. (Courtesy University Archives CSU Stanislaus.)

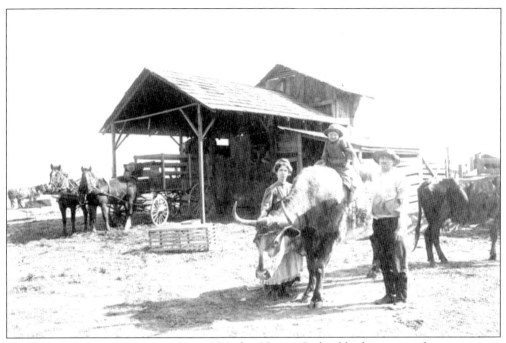

Man was continuing to wage war against Mother Nature. Jack rabbit hunts were frequent events where hundreds of rabbits would be shot and marketed. Locusts were a continual problem, as were the geese. The story was told that the family ox, in this photo, helped coax the geese out of the grain fields. Moving slowly through the field as a decoy, the ox would flush out the geese, moving them to the edges of rows where they were shot and gathered up by the farmer. (Courtesy Mike Ertmoed Collection.)

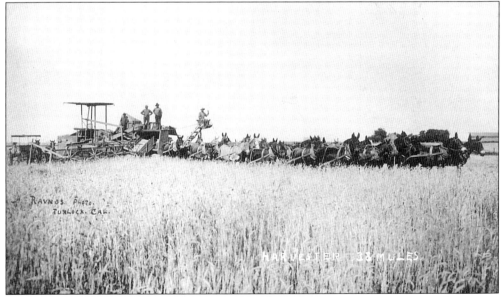

Increasing the number of acres cultivated and continuing improvements in harvesting techniques increased production and prosperity. Stanislaus County was named number one in grain production in 1871. (Courtesy Turlock Historical Society.)

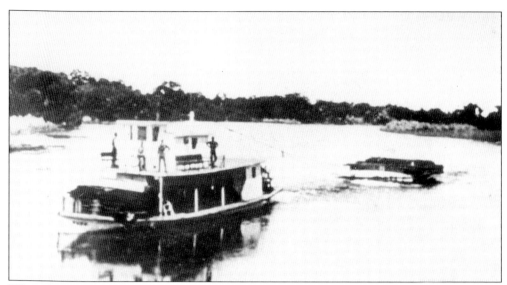

When the settlements in the valley began to develop, the river was the link to the world. Most goods were transported by river steamer and barge on the Tuolumne River. The closest and largest port was Stockton, where goods could continue by water to and from Sacramento or San Francisco and the world beyond the Golden Gate. However, the river had limitations that restricted the size of the steamers and the weight capacity of the barges, and prevented navigation on the river four months of the year. (Courtesy University Archives CSU Stanislaus.)

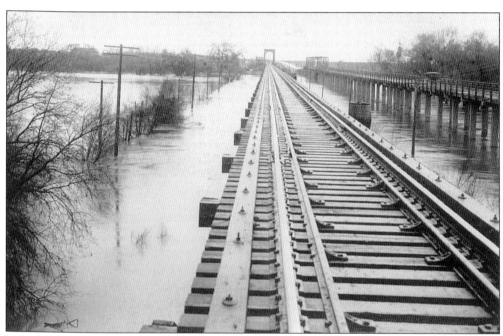

Pile drivers rumbled and hundreds of men of Irish and Chinese descent labored as the railroad tracks were laid. The trestles were finished and the train moved closer and closer to Turlock. Anticipation was high in early newspaper accounts of 1871 as the promise of the railroad was soon to be a reality. (Courtesy Mike Ertmoed Collection.)

Two
THE IRON HORSE

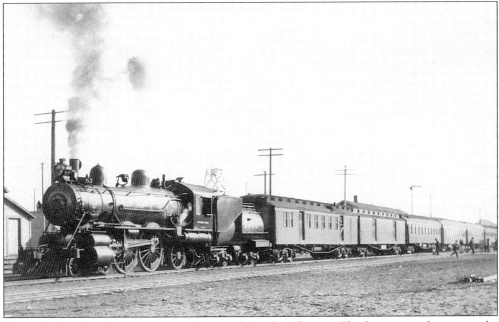

The valley's railroad was constructed primarily by the Chinese. The line across the soon to be named Turlock region, south to the Merced River, was completed in just six months. Soon after its completion people left river and mining towns hoping to find better business opportunities along the railroad. Some of the new businessmen moved their buildings in from towns such as Westport and Empire because lumber was in short supply. The new town and the post office needed a name and Clark Lander, the first postmaster, sent the name "Sierra" to the postal authorities in Washington D.C. The name was not accepted because there was a county named Sierra and they felt it might cause confusion. Clark's brother, Henry, had been reading a Harper's Weekly article that mentioned a place called Turlock. He liked the sound of it and suggested it as a possible name. Lander's submission was approved and the town and post office were officially named Turlock. (Courtesy Turlock Historical Society.)

Stephen and Florence Porter (on the left) and Florence's two brothers, Clark and Henry Lander, lived in one of the farmhouses Mitchell had built to encourage newcomers to the area. Clark Lander was the first postmaster for the area and he established the first post office in the Porter's home. Some say that the first religious services in Turlock were held in 1868 in the home of the Porters. Turlock's first church, the Methodist Church, was erected on the corner of West Main and Lander Avenue in 1888 on land donated by the Porters. Ten years later the building was sold to satisfy the mortgage, and the congregation disbanded, to reorganize in 1906 and meet again in the Porter home. Stephen Porter, who came to Turlock as a farmer, became a railway engineer from 1876 until his death in 1912. (Courtesy Robert Brown Collection.)

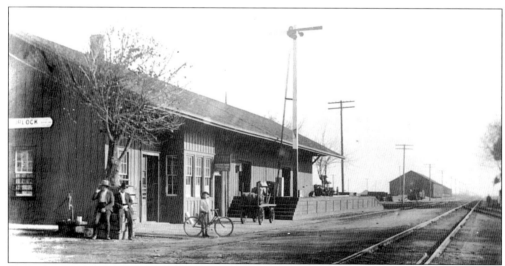

Turlock's first passenger and freight depot was completed about September 1871. Built as the Central Pacific Depot it was later changed to the Southern Pacific. This depot was the first sight that many pioneering families saw as they stepped off the train in Turlock. Gone were the tiresome wagon rides from the end of the line south to Turlock. The depot was the hub of shipping; agricultural products, goods, and equipment heading to market arrived on a regular basis. (Courtesy Robert Brown Collection.)

The Turlock Hotel located on Front Street (now Golden State Boulevard) near Main was owned and operated by James Allen. His wife Eliza continued to operate the hotel after their divorce in 1881. The hotel was moved in from Westport and became Turlock's first hotel. Advertisements in the valley papers enticed weary travelers to the hotel, promising good lodging, home cooked meals, and some liquid refreshments from its bar. (Courtesy Robert Brown Collection.)

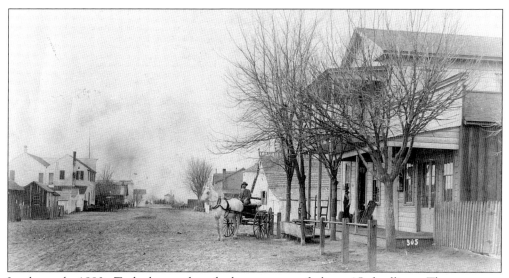

In the early 1880s Turlock was described as a town of about 15 dwellings. The two-story building on the right of this picture was the Howell Brothers' Grocery Store, and the two-story building on the left was the Giddings & Ward store. This general merchandise store was moved as a one story building from Empire in 1871 and remodeled c. 1880. It carried a wide variety of dry goods as well as remedies and medicines. Turlock had numerous saloons. The one story structure on the right side of the picture is the J.C. (Dad) Purdy Saloon. He and his partner, James Anderson, named it "No Place." Turlock also had five grain warehouses, a couple of hotels, and blacksmith shops. A butcher shop and a barbershop were located in one of the many saloons. (Courtesy Robert Brown Collection.)

This wagon was built in Tom Fulkerth's blacksmith shop in 1878. The shop was located at Center and East Main. This type of wagon was often seen on Turlock's unpaved roads transporting the farmer's produce to the railroad depot for shipping. (Courtesy University Archives CSU Stanislaus.)

This was the first house built in the townsite of Turlock. It was built about 1870 by Elijah Giddings on South Center near Crane. Most of the pioneers that came to the area lived on nearby farms, resulting in Turlock's business structures outnumbering residential structures. The Giddings home was sold after the death of both Elijah and Emily Giddings. Their son, Ralph P. Giddings, is credited with being the first child born in the town of Turlock on May 14, 1872. When he and his sisters were orphaned, Ralph had to work but was able to attend school. In February of 1915 he was appointed postmaster of Turlock. Giddings married and remained in Turlock, actively participating in his postal work. He worked to establish city government and supported community activities. (Courtesy Robert Brown Collection.)

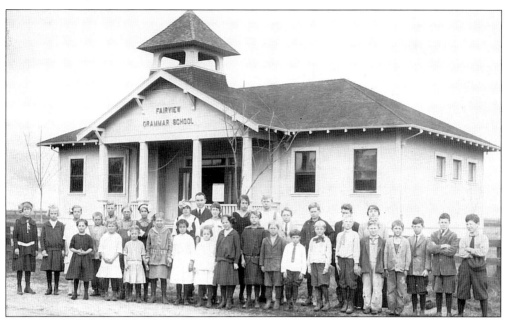

John Mitchell donated land for the Fairview Grammar School, which was completed in 1868. The school opened with one teacher and fifteen pupils classified not by grade but by beginning through fifth readers. About 1881 the school building was moved to the town site on East Main near today's Thor Street. The school's name may have been changed to Washington School but the building was replaced by Washington Hall and the students awaited a new school. (Courtesy Turlock Historical Society.)

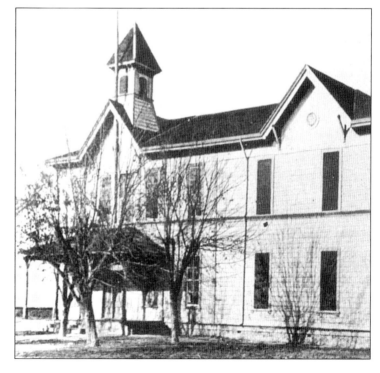

The new school, named Fairview School and completed in 1885, was built at West Main and Lander. The first annex on the east side was added after completion and a second was added to the back in 1904. Anticipating the arrival of irrigation water for the valley's sandy farmland, the population rose and in 1902 school enrollment went from 60 to 500 and teachers from 2 to 11. The district began making plans to have two new schools, Hawthorne and Lowell, ready by 1910. (Courtesy Robert Brown Collection.)

Newcomers to the developing prairie that would become Turlock found little or no available housing when they arrived. Some settlers built lean-to temporary housing, adding on as supplies were available or finances permitted. Water was hauled by bucket to be used for drinking, cooking, and washing. Tallow was used to make candles for light. Men and boys hunted wild ducks and geese for food. Feathers and straw were used to fill the ticking mattresses. (Courtesy Robert Brown Collection.)

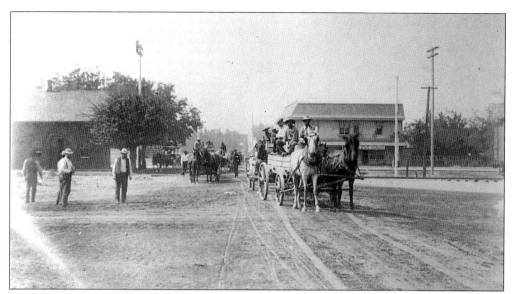

For $2,500 Henry Osborn bought a building on the northwest corner of First and West Main (Osborn Store and wagon pictured above). The general store carried everything from groceries to furniture to farm implements. When the fire of 1893 swept through Turlock, the Osborn store, which was somewhat isolated from other stores, and the Grange Building, farther up the railroad track, were the only ones left standing. (Courtesy Robert Brown Collection.)

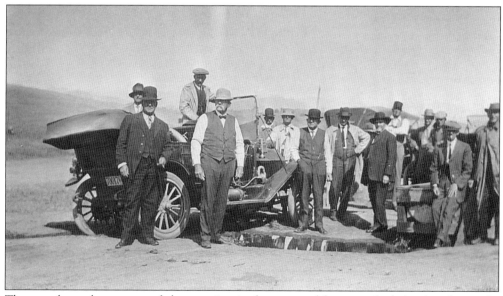

These early settlers, many of them active in farming and business, laid the foundation for making Turlock the prominent city that it is today. A few of the men pictured are Tom Gaddis, Stephen Crane, and his son, Horace Crane. (Courtesy Turlock Historical Society.)

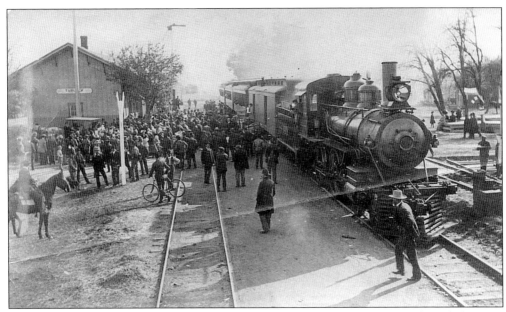

The railroad was a great service to the farmers. Seven years after completion, three daily trains were in service carrying carloads of wheat between Turlock and Stockton. The trains were usually composed of about 40 cars and each car could transport about 24 tons of grain. Today Turlock has become a leading agricultural town and a living tribute to the importance of the "Iron Horse." (Courtesy Robert Brown Collection.)

This tintype (an early form of photography) taken about 1885 shows the Le Cussan Saloon and barbershop. (Courtesy Robert Brown Collection.)

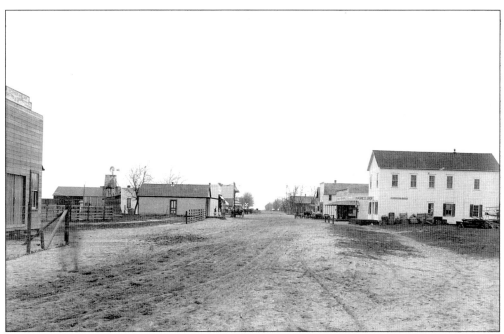

This is a photograph from the corner of Lander and West Main. It shows a good view of Main Street's unpaved surface with the town's wooden structures in the distance. (Courtesy Mike Ertmoed Collection.)

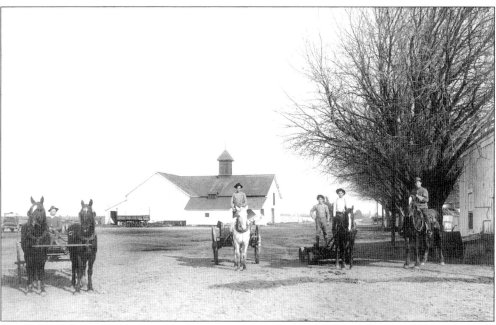

The birth of the railroad encouraged people to come from the Midwest to farm Turlock's fertile soil. Because of the railroad, ranchers could haul their grain and melons to the train depot to be shipped and make the return trip home with a wagonload of supplies. The round trip generally took three days: one day hauling the grain to town and two days to load and return home. (Courtesy University Archives CSU Stanislaus.)

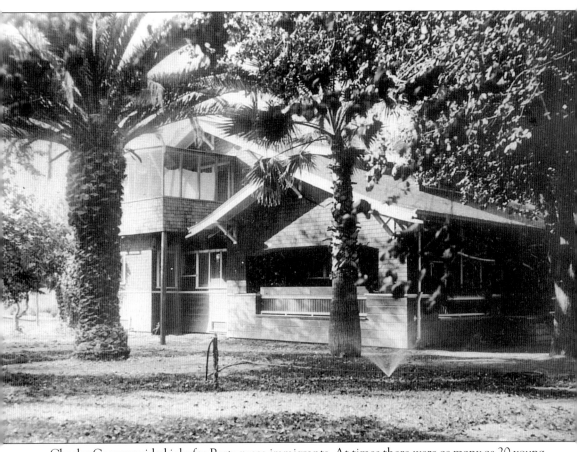

Charles Geer provided jobs for Portuguese immigrants. At times there were as many as 20 young men in the Geer bunkhouse. The ranch hands wages were $30 a month. Pictured above is a Geer ranch house north of town. (Courtesy Robert Brown Collection.)

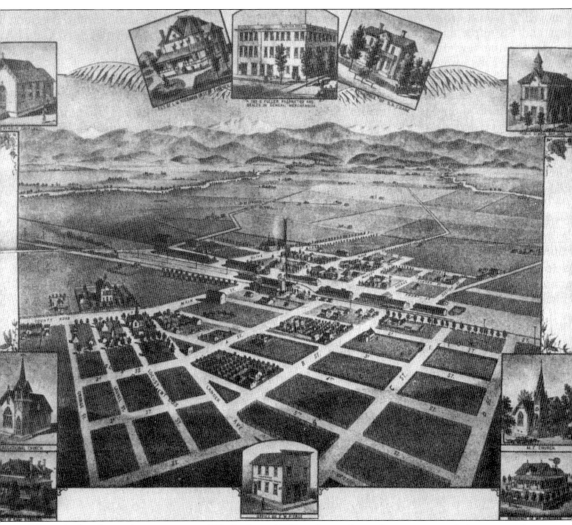

This idealized aerial perspective of Turlock in 1888 is drawn from the west toward the east and the Sierra mountains. Main Street is identified as well as Front Street, Olive, and others. It is easy to locate the railroad tracks and shipping buildings. Some of the other buildings shown as inserts are the Methodist Episcopal Church, Fairview School, Crane home, Fuller General Merchandise, Catholic Church, Donovan structure, Congregational Church at Center and Olive, and the residence of Sam Strauss. (Courtesy Turlock Historical Society.)

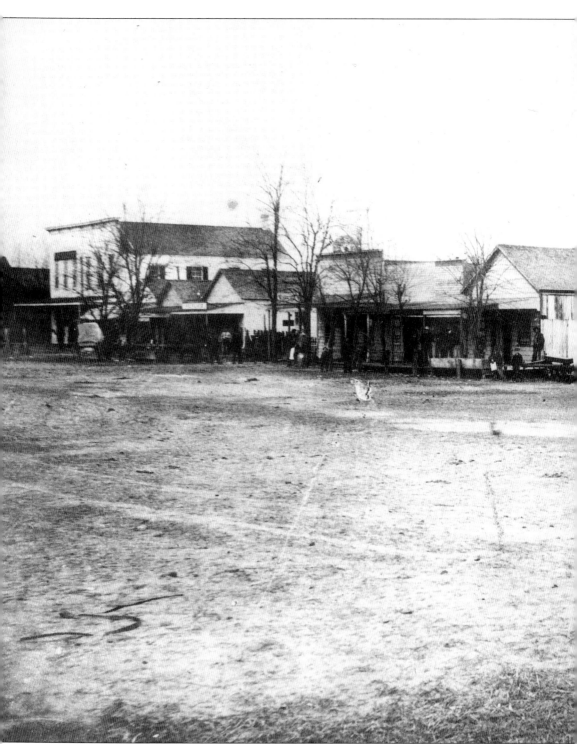

A devastating fire broke out at 10:30 the night of October 3, 1893. It started in the rear of the shoe store near the middle of the block. The wooden buildings burned both directions until it reached the street on either side. The shoemaker in whose place of business the fire started lived

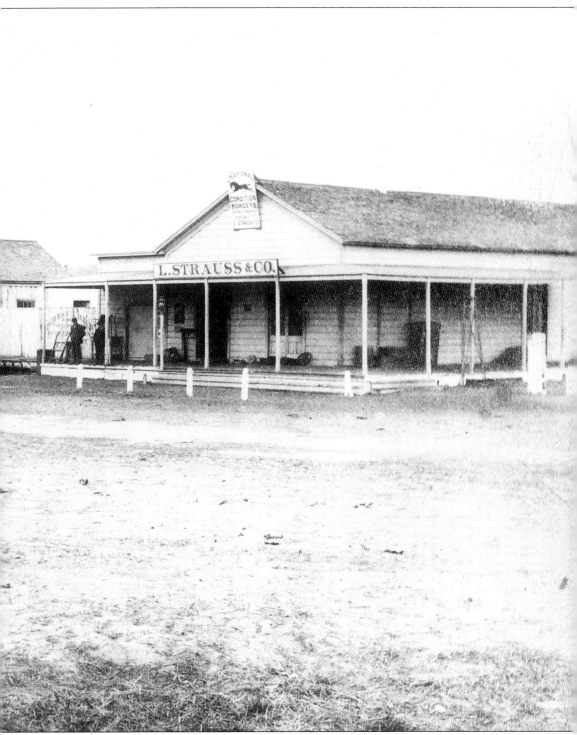

in the back of his shop and cooked his food on an oil stove. He set his place on fire two or three other times due to his carelessness. The town was not rebuilt until after 1902, when the Swedes and the Portuguese began to settle in Turlock. (Courtesy Robert Brown Collection.)

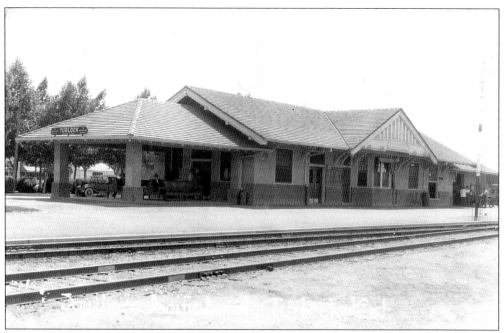

Local citizens were reported to have danced in the street in 1915 when a sale of bonds was approved to build a new and modern passenger depot in Turlock. The original depot was moved to West Olive and First Street and used as the freight office. The railroad built the new depot to the city council's specifications and it remained in service until Amtrak took passenger travel to the Santa Fe tracks with a stop in Denair. (Courtesy Turlock Historical Society.)

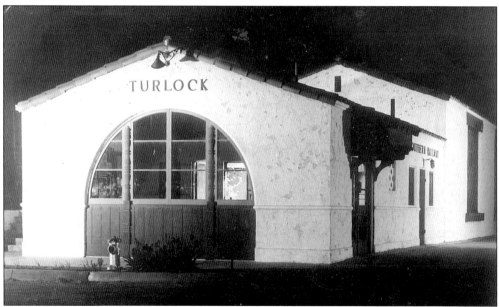

Turlock's forgotten depot, on the Tidewater Southern tracks at Broadway and B, was completed in 1913 but never used. The full effects of the Depression forced the Tidewater out of the passenger business and the depot still sits today as the ghost of progress past. (Courtesy Turlock Historical Society.)

Three
IMMIGRATION AND THE FAMILY FARM

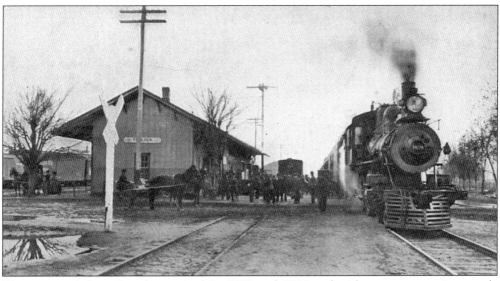

The greatest influx of settlers arrived in 1903 and 1904 and with great expectations made Turlock their home. Advertisements and the letters of family already settled told of the milder climate (less harsh winters that the east and midwest), the cheap land prices, and the promise of abundant water for irrigation. Most settlers traveled to Turlock by train. Oftentimes the women and small children rode in the passenger cars while the men and older boys rode in the boxcars with the family's belongings and livestock. (Courtesy Mike Ertmoed Collection.)

Nels O. Hultberg, originally from Sweden, arrived in Turlock in January, 1902. At the time damage from previous fires had not all been repaired. Hultberg heard that irrigation water was coming and gathered soil samples that verified the area would be suitable for colonization if water was available. Hultberg met Horace Crane, secretary/treasurer of the Fin de Siecle Co. The company was formed to sell off the land of the deceased John Mitchell. Hultberg went to work for Fin de Siecle as the land sales promoter. Hultberg and silent partner Walter Soderberg started their own land company and secured about 35,000 acres for colonization as well. In 1902, 17,000 of those acres were plotted out and named Hilmar. Through extensive advertising in the Midwest, Hultberg enticed Swedish families to settle here. (Courtesy Turlock Historical Society.)

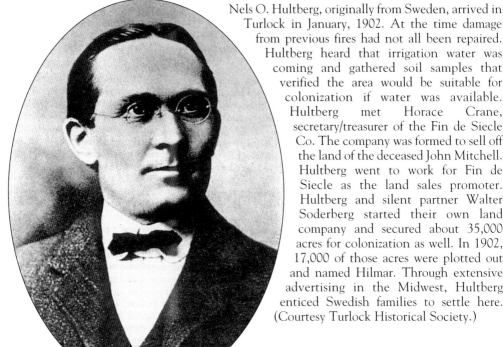

Nels Hultberg could not handle all the responses to his advertising by himself. He needed a secretary who could speak and write in Swedish and English. Miss Esther Hall had graduated from a business college in Minneapolis and heard about the job opportunity when visiting San Francisco. Esther was hired for the position and started work when she arrived December 26, 1902. Esther later married Arthur Crowell. (Courtesy Turlock Historical Society.)

When the land holdings of John Mitchell were subdivided and sold other tracts followed suit. Twenty to forty acre family farms began to dot the landscape. Land prices were cheap and one family could manage their own land. The promise of irrigation water convinced the settlers their farm would be profitable and their land value would increase. Conditions were often hard, but their determination helped them persevere. (Courtesy Turlock Irrigation District.)

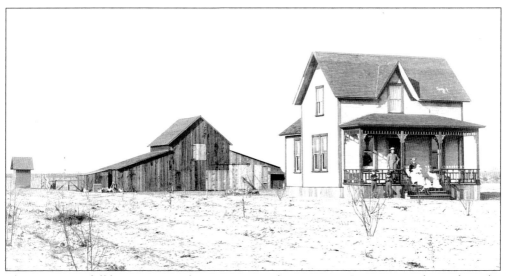

The Henry Lundell home in 1903 demonstrates settlers' success. Homes were a far cry from the "soddies" of the midwest. The wooden outbuildings reflected the low western style with the hay loft in the center. (Courtesy Mike Ertmoed Collection.)

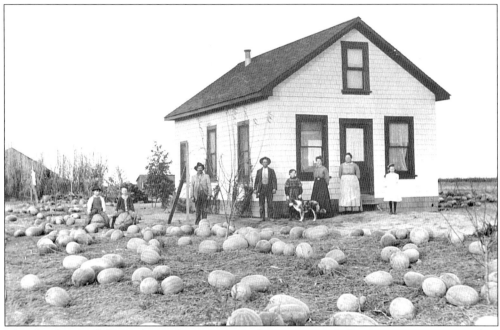

This family posed for a photo that was printed as a postcard. Farmers were encouraged to cultivate as much land as they were able in an attempt to pay off the land debt as soon as possible. Once the debt was paid, they often added to the house or built outbuildings. (Courtesy University Archives CSU Stanislaus.)

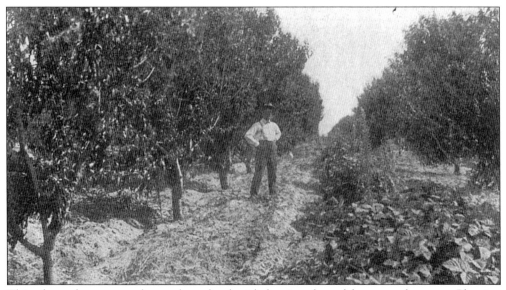

This photo shows an early peach orchard with berries planted between the trees. Planting berries helped prevent topsoil erosion and brought in extra cash during the growing season. (Courtesy Turlock Historical Society.)

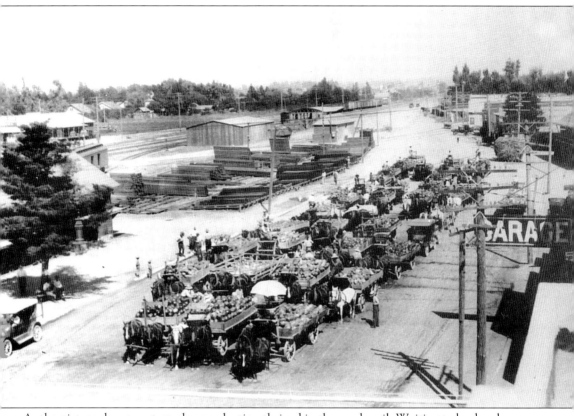

As the picture shows, watermelon production thrived in the sandy soil. Waiting to load melons on trains for the journey to market often involved a major traffic jam longer than a parade. (Courtesy Robert Brown Collection.)

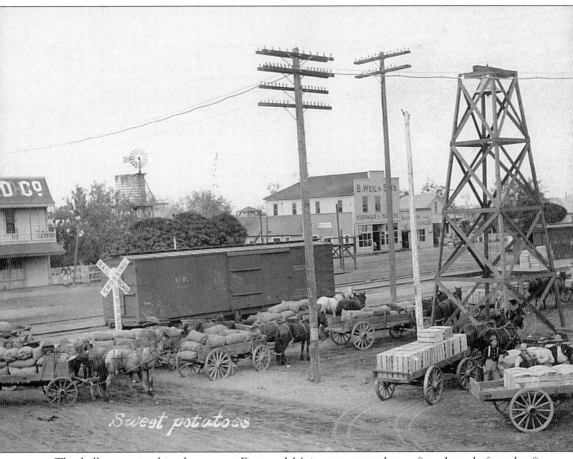

The bell tower in this photo near First and Main was erected as a fire alarm before the fire department was organized. When the bell sounded bucket brigades and wet sacks were used to fight fire. The men in the photo are waiting to load their sweet potatoes for shipment to market. The Stanislaus County Chamber of Commerce brochure of 1907 told of the profitable yield with sweet potatoes as Turlock's soil and conditions were ideal for the crop. The brochure recommended sweet potatoes to the new settler who wanted a quick crop that would pay for the land in one season. (Courtesy Mike Ertmoed Collection.)

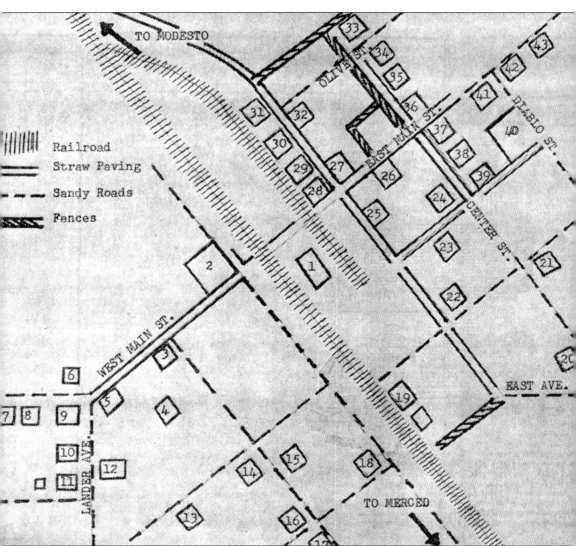

When people arrived in 1903, the Turlock map looked very much like this one. The streets with the locations of businesses and residences are the recollections of Esther Hall Crowell when she began working for the Fin de Siecle Land Co: 1) Railroad depot; 2) Osborn Store, Post Office, FindeSiecle, Hosmers with apartments overhead; 3) Gaddis Hall upstairs; 4) Gaddis residence; 5) Osborn residence; 6) two-room school; 7) Johnson's; 8) vacant; 9) Swedish Church; 10) Porter residence; 11) Seims residence; 12) Lundahls; 13) Chatom residence; 14) Donovan residence; 15) Constable Parker residence; 16) vacant; 17) Catholic Church; 18) Brown residence; 19) vacant warehouses; 20) Chinese laundry; 21) Dwyer's residence; 22) Dr. Monnett; 23) Livery; 24) barn; 25) Morgan Saloon; 26) Wolfe residence; 27) Turlock Hotel; 28) vacant; 29, 30) Warehouses; 31) Modesto Lumber; 32) Donkins; 33) Brethren Church; 34) Fulkerths; 35) Klein residence; 36) Strauss Store; 37) McGill Blacksmith; 38) Strauss residence; 39) Crane residence; 40) Crane barn; 41) boarding house; 42) Elmores; 43) McGills. (Courtesy *Turlock Journal*.)

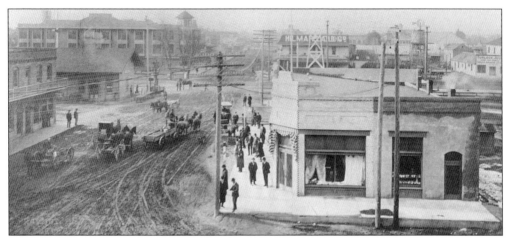

From Front Street this shows Turlock c. 1909 looking West down Main. The brick building on the left is the Santos Saloon with the depot behind it. Across the tracks at First Street is the St. Elmo Hotel. On the right is the Hultberg/Lane building, later known as Mowrer's Corner. The door on the far right was the entrance to one of the early locations of the City Library. (Courtesy Turlock Historical Society.)

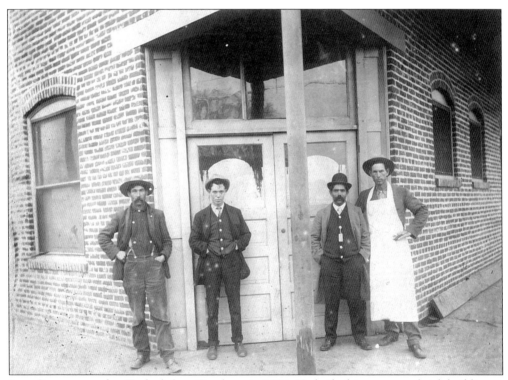

Jesse Santos moved to Turlock from Stockton in 1904. He built this two-story brick building at Main and Front, which housed the Santos Saloon, a Greek restaurant, (the library for a short time) and two offices Santos rented out. Around 1909 the city learned that John Mitchell had deeded the property to the city for a park. The city purchased the building from Santos, tore it down, and today the site remains Central Park. (Courtesy Mike Ertmoed Collection.)

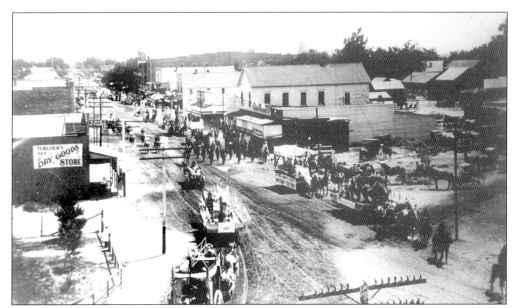

Turlock citizens have consistently enjoyed parades and demonstrations of patriotism. It is believed this early 4th of July parade photo is from 1908, the same year of incorporation as a city. This vantage point near Market Street and later, Lander Avenue, looking east on Main has been and perhaps still is the most photographed location of downtown Turlock. (Courtesy Robert Brown Collection.)

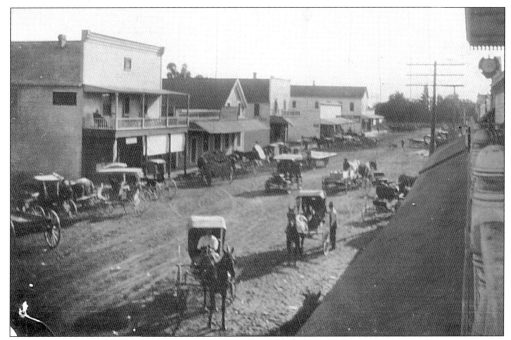

This photo of West Main with the Miar's Hotel on the left was taken prior to the fire on February 2, 1910. Around this time a fire zone ordinance was passed requiring brick, iron, or concrete exterior and center walls in the central business district. (Courtesy Turlock Historical Society.)

Turlock's Literary Society brought the communities together to recognize their mutual, cultural interests. They hosted musical recitals, recitations, and current event debates. The Society planned the funding and building of the Opera house, completed May 26, 1905, for public and private meetings and entertainment. (Courtesy Robert Brown Collection.)

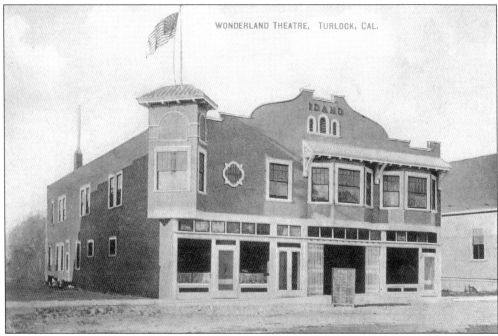

"One of the finest moving picture theaters in the West" was the claim when the Wonderland Theater opened in 1909. The audience favored the large, clear pictures, illustrated songs, and "electric" piano. The Wonderland Theater was in the Idaho building on Second Street (now Broadway). Charles Johnson, the proprietor of the theater, was formerly from Idaho Falls, Idaho. (Courtesy Robert Brown Collection.)

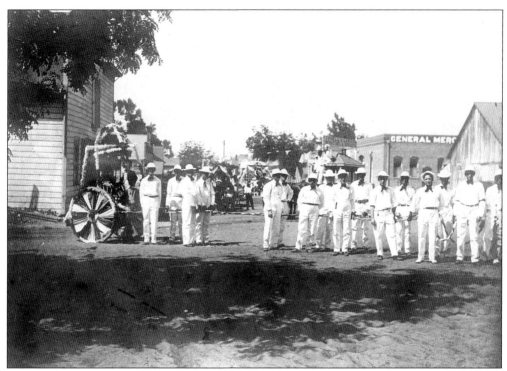

Turlock firemen were proud to show off the department's hose at the 1908 4th of July parade. The fully decorated hose cart is carrying the first "fire queen," Mrs. Chamberlain. (Courtesy Turlock Fire Department.)

The Ramona Hotel was built in the late 1800s on the east side of Second Street. It was in the 100 block of South Broadway just behind the buildings facing Main. In 1909 the proprietor, Joseph Samuelson, leased ten additional rooms in the newly completed Enterprise block on West Main for guests. (Courtesy University Archives CSU Stanislaus.)

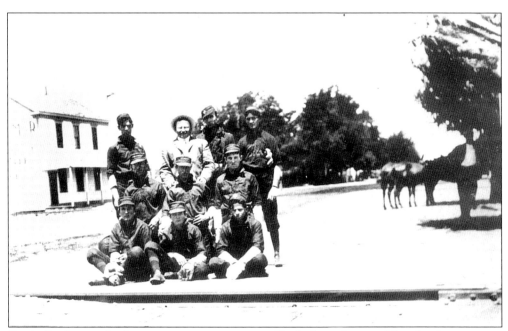

Baseball, America's favorite pastime, came to Turlock early on. This local team was photographed around 1904. Visible among the trees is the Turlock Hotel with the California Land Office, built in 1887, in the background. (Courtesy Robert Brown Collection.)

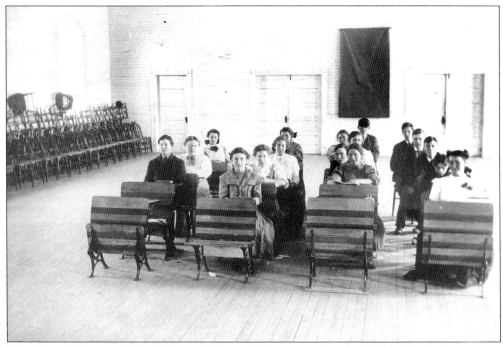

The Opera House at West Olive and Second Street was also the high school classroom in September 1906. Twenty students learned English, history, mathematics, and Latin under the instruction of Principal S.R. Douglas and Miss Maud Clark. (Courtesy Robert Brown Collection.)

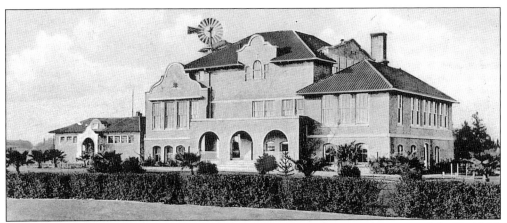

Turlock's first high school was approved with a bond issue for construction on July 23, 1906. The school facing Locust Street at High and Laurel Streets was opened in 1907. A.G. Elmore is credited with raising the issue of having a high school to the Turlock Board of trade. H.C. Hoskins was made chairman of the Board of Trustees in 1906 when Washington, Central, Mitchell, Tegner, Keyes, and Turlock grammar school districts joined to form the Turlock High School District. Around 1910 the library contained more than 170 books. A science and art annex was added around the same time. In 1912, temporary structures were built for a gymnasium and study hall. (Courtesy Turlock Historical Society.)

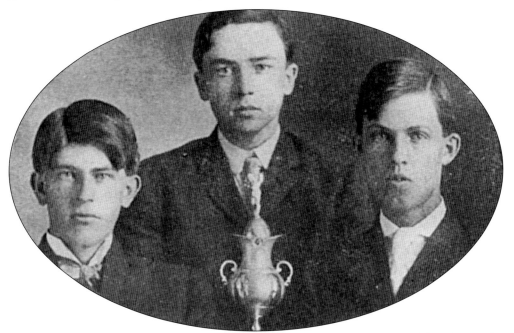

In 1907, the only inter-school activity was the debate team. Try-outs were held to choose the team and L.V. Hoskins, Manley Sahlberg, and Chesley Osborn (left to right) answered the challenge from Orestimba Union High School of Newman. On March 29, 1907, in their first interscholastic debate, which was also the school's first interscholastic meet of any kind, Turlock was victorious. Judges Mr. J.W. Webb of Modesto, Mr. Williams of Newman, and Mr. Wolford of Turlock awarded the victory by unanimous decision. The silver cup was brought home to Turlock by the proud team. (Courtesy Turlock Historical Society.)

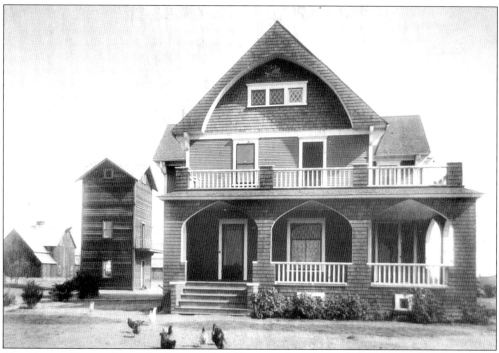

The George Simons home, built around 1905, was referred to as "the Hawkeye Ranch." The property was later sold to James Henry "Cantaloupe" Smith, successful owner of the Turlock Fruit Company. Descendants of "Cantaloupe" Smith live in the home today. (Courtesy Robert Brown Collection.)

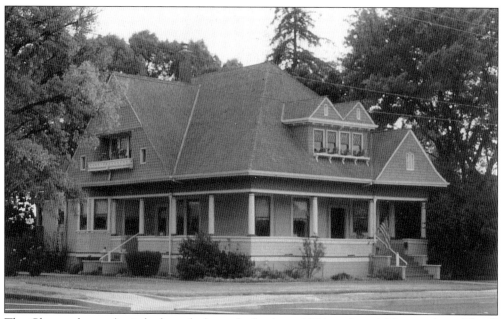

The Chatom house (as it looks today) was built about 1906 at A and Morgan (now Third) Streets. The house stands as a proud reminder of those early days when irrigation brought a large influx of settlers who persevered on the land.

Four
THE WEDDING OF THE LAND AND THE WATER

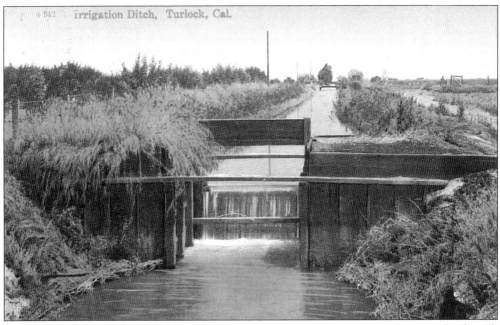

In 1886, local farmers knew the heavy grain production was wearing out the once fertile soil. They also knew that during dry years, the Tuolumne River dwindled to a trickle in midsummer. Crops could be ruined and farmers nearly driven to bankruptcy. Farmers were looking to irrigation and new crops to bail them out. (Courtesy Turlock Historical Society.)

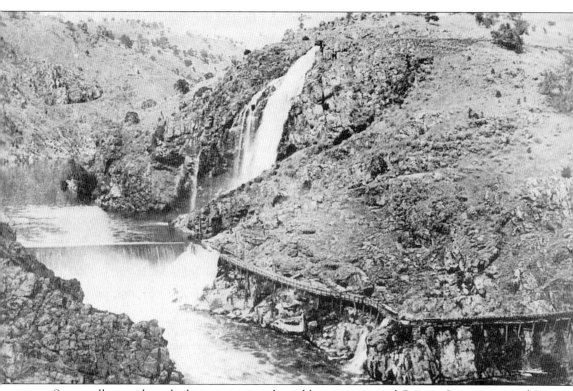

Some valley residents had spent time in the gold country around Sonora, Jamestown, and La Grange before settling down as farmers. They had seen the ditch system and dams that diverted natural run-off and rivers to supply adequate water to the massive mining operations. One such dam, built on the Tuolumne River, was owned by M.A. Wheaton and supplied water for milling, mining, and irrigation near La Grange. (Courtesy Turlock Irrigation District.)

In the election year of 1886, the farmers' cry, "give us water, and the money will come," was gaining popularity. Locals supported Modesto attorney C.C. Wright's candidacy for state legislature. Wright ran on an irrigation platform that advocated a new kind of local government, an irrigation district. Wright was elected and his bill, The Wright Act, was signed into law March 1887. (Courtesy Turlock Irrigation District.)

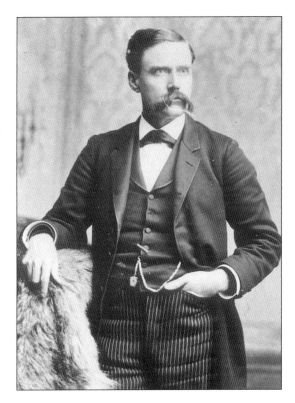

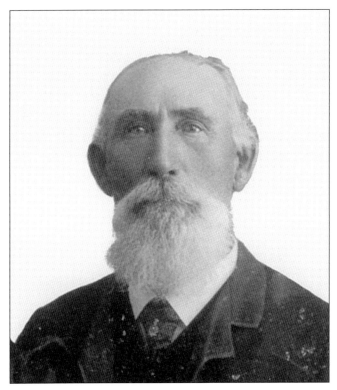

The proposal to form an irrigation district went to the voters on May 28, 1887, and on June 6, 1887, the Turlock Irrigation District became the first district in the state under the Wright Act. The first Board of Directors, E.V. Cogswell of Hickman, R.M. Williams of Ceres, E.B. Clark of Westport, J.T.Dunn of Merced County, and W. L. Fulkerth of Turlock, (pictured) met on June 15, 1887. (Courtesy Turlock Irrigation District.)

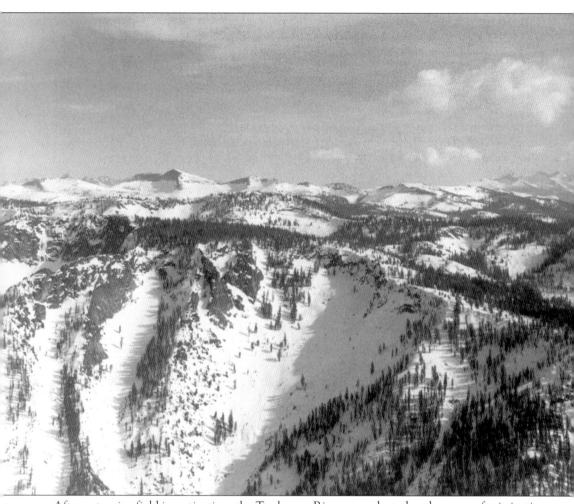
After extensive field investigation, the Tuolumne River was selected as the source for irrigation water. The river drains a basin of 1,880 square miles and flows westerly into the San Joaquin River, a distance of about 150 miles. From its headwaters on the northern slope of Mt. Lyell it flows through upland meadows, then through a canyon of granite 80 miles long, then through the Hetch Hetchy area, down to the La Grange area, and out across the valley to the San Joaquin. (Courtesy Turlock Irrigation District.)

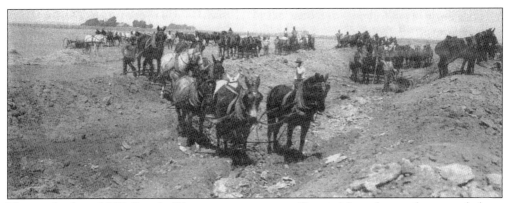

The newly elected TID Board of Directors put engineer George Manual to work on canal plans. When excavation of the canals began, it was done the hard way, with manpower, horsepower, and mulepower. (Courtesy Turlock Irrigation District.)

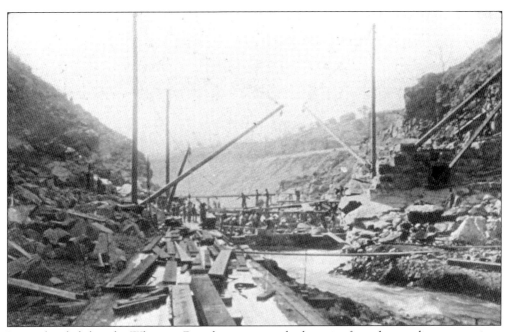

It was decided that the Wheaton Dam location was the best site for a dam to direct water into a canal system. In August, 1890, TID and the Modesto Irrigation District jointly bought out Wheaton. The LaGrange diversion dam was begun in 1891, completed in 1893 and was the highest overflow dam built at that time. (Courtesy Turlock Irrigation District.)

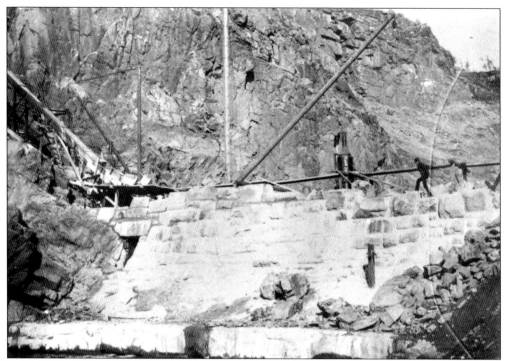

The original dam was built of Cyclopean Rubble, faced with rough-dressed stone in cement mortar. The rock was quarried out of a bluff on the right bank of the river. (Courtesy Turlock Irrigation District.)

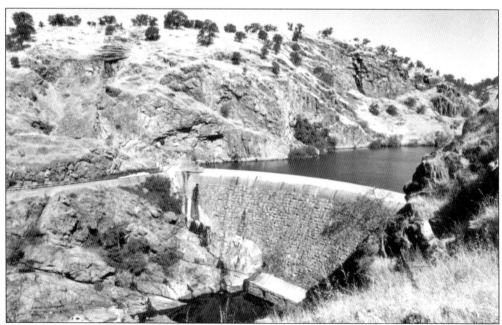

When completed, the dam was 129 feet above the stream bed. The length of the dam on top is 336 feet curved on a radius of 300 feet. The thickness at the base is 90 feet and at the top 24 feet. A power plant would later be built at the La Grange Dam site. (Courtesy Turlock Irrigation District.)

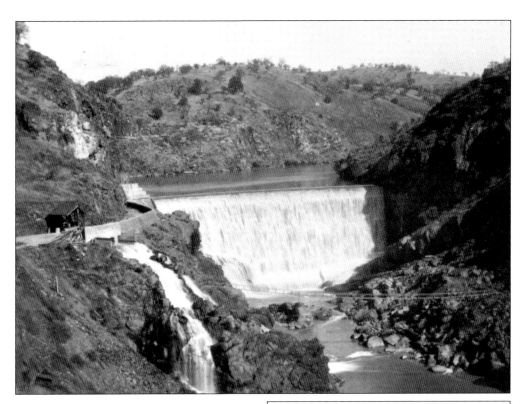

Financial problems plagued the TID as the dam was being finished. Falling crop yields and a collapsing wheat market forced farmers to let their irrigation taxes go unpaid. At the same time, political opposition to the district was increasing. Anti-irrigationists filed injunctions and countless lawsuits to have TID bonds and taxes declared invalid. Suits were filed to declare the Wright Act unconstitutional. (Courtesy Turlock Irrigation District.)

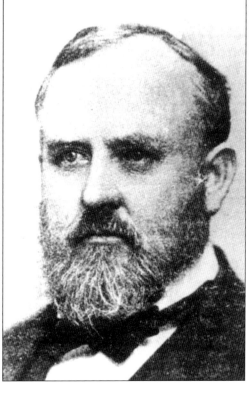

As TID struggled, Judge James A. Waymire of Oakland came to the rescue. He offered to complete the canals in exchange for the devalued and shunned construction bonds. Waymire's crews completed the canals but bond prices did not increase before the Judge's mortgaged assets were lost. Judge Waymire also retained former President Benjamin Harrison to argue the case before the U.S. Supreme Court. When the Court ruled to uphold the Wright Act, Waymire became the savior of the Turlock Irrigation District. (Courtesy Turlock Irrigation District.)

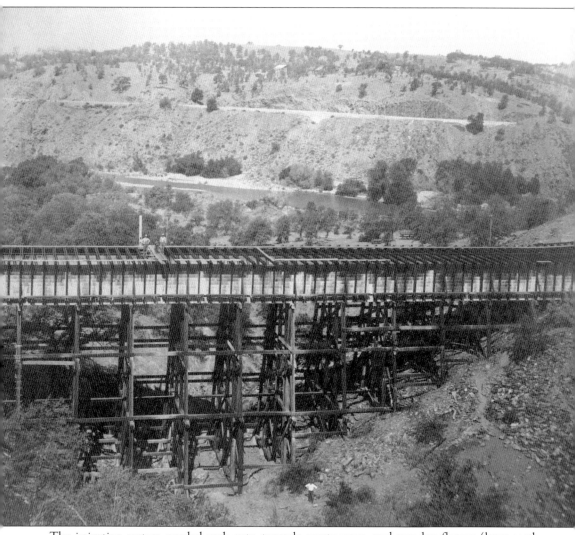

The irrigation system needed rock cuts, tunnels, waste ways, and wooden flumes (later earth-filled), to bring water from the dam to a point called the division gates 23 miles away. From that point the main lateral system of canals would irrigate the 180,000 acres of the district. (Courtesy University Archives CSU Stanislaus.)

In March 1900, Henry Stirring's farm was the first to receive water from the 60 mile canal system and in 1901, 3,757 acres were irrigated. On April 21, 1904, Governor George Pardee opened the three-day celebration, confirming the "successful wedding of the land and the water." Train excursions took visitors to view the MID and TID main canals, the laterals, and the new, flourishing crops. (Courtesy Turlock Historical Society.)

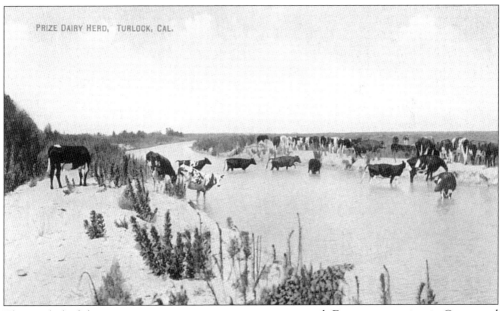

The symbol of the new economy was now an irrigation canal. Figs were growing in Ceres, and orchards, new crops, alfalfa, and herds of dairy cows were all thriving with the irrigation water. Two large creameries passed the million pound mark of exported butter in 1903. (Courtesy Turlock Historical Society.)

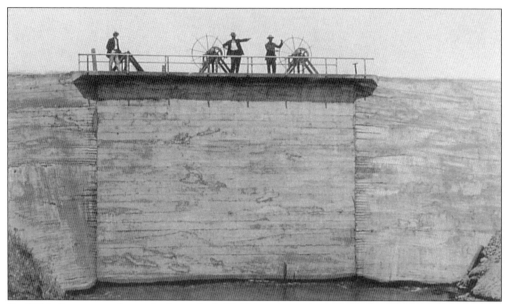

By 1913 the irrigated area had reached 85,002 acres and in the late summer months, water shortages occurred. The Davis Reservoir, later named Owen Reservoir and now called Turlock Lake, was constructed in 1913. Seventeen dams and levees and one outlet gate structure were required to complete the 50,000-acre-foot capacity storage reservoir. (Courtesy Turlock Historical Society.)

Born in 1884, Roy V. Meikle attended Portland, Oregon schools and studied Civil Engineering at Stanford University. Meikle had been loaned to TID in 1912 by the U.S. Department of Agriculture. In 1913, he led a survey party into the Tuolumne canyon, mapping a new reservoir site near the old gold mining camp of Don Pedro's Bar. Meikle officially joined TID in 1914 and served as Chief Engineer until 1971. He was the Chief Project Engineer during the building of the old Don Pedro Dam and oversaw completion of the new Don Pedro Dam in 1971. Today, Roy Meikle's 57 years of leadership with the District are legendary. His forward thinking and educated planning have made him a major figure in the history of the Turlock Irrigation District and its success. (Courtesy Turlock Irrigation District.)

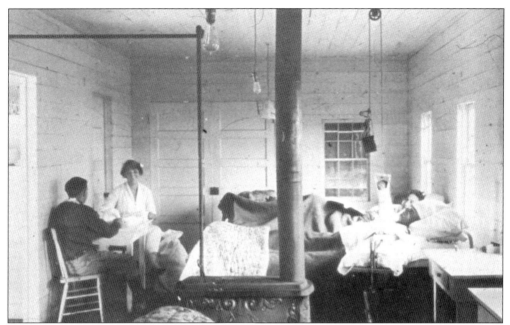

As early as 1913, plans for a larger reservoir to be called Don Pedro were developed. In 1916 the Department of the Interior approved the permit to use government land for reservoir purposes. When estimates came in too high, the Modesto and Turlock districts agreed to build the dam themselves with Roy Meikle as Chief Project Engineer. A railroad branch was built to the site and a construction camp was set up in the hills. The camp had bunkhouses, tents for married men, a bakery and mess hall, a recreation facility and a hospital (pictured above). (Courtesy Turlock Irrigation District.)

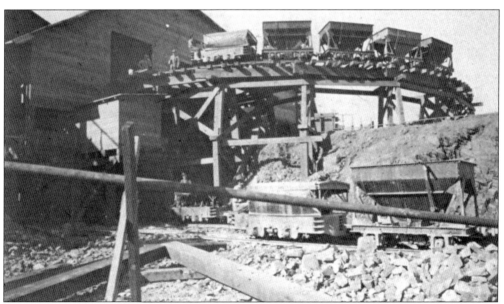

A concrete plant was constructed near the dam site. Large cement mixers were installed that were capable of making more than a thousand cubic yards of concrete per day. The amount of concrete placed in the dam and spillway totaled 296,552 cubic yards. (Courtesy Turlock Irrigation District.)

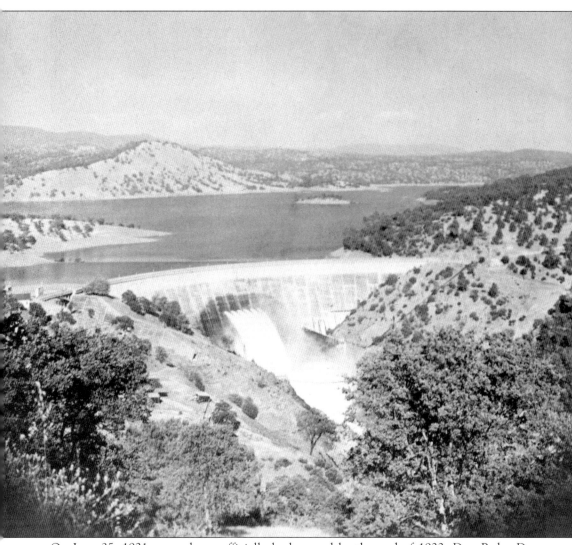
On June 25, 1921, ground was officially broken and by the end of 1922, Don Pedro Dam, powerhouse, and spillway were nearing completion. A year later, the reservoir crested, storing 289,000 acre feet of water. (Courtesy Turlock Historical Society.)

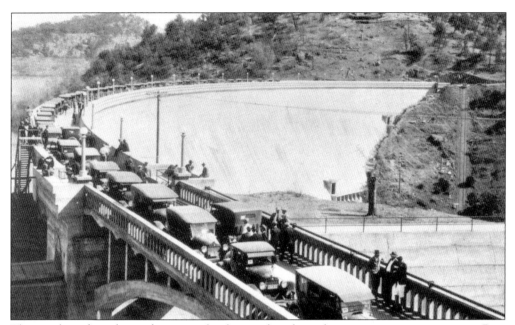

The number of cars being driven on the dam in this photo demonstrates its immense size. Don Pedro was 284 feet above the stream bed and the length on top was 1,040 feet. The concrete dam was of the solid gravity type, arched in plan, 16 feet thick at the crest, and 177 feet thick at the base. (Courtesy Turlock Irrigation District.)

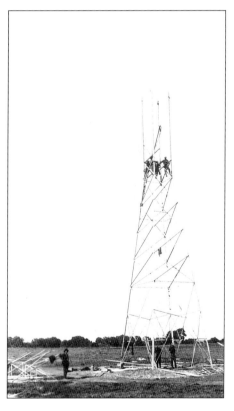

It was said that the harnessing of potential hydroelectric power on the Tuolumne would drastically transform the lives of valley residents, especially farmers in rural areas. Under the direction of Electrical Engineer R.W. Shoemaker, the 66,000 volt main transmission line was constructed. TID was the first power company to use aluminum high-tension wires. Power came from the powerhouse to the newly built Geer substation at Monte Vista Avenue on Easter Sunday, 1923. As power distribution began, TID became the first California irrigation district to sell its own power to retail customers. (Courtesy Turlock Historical Society.)

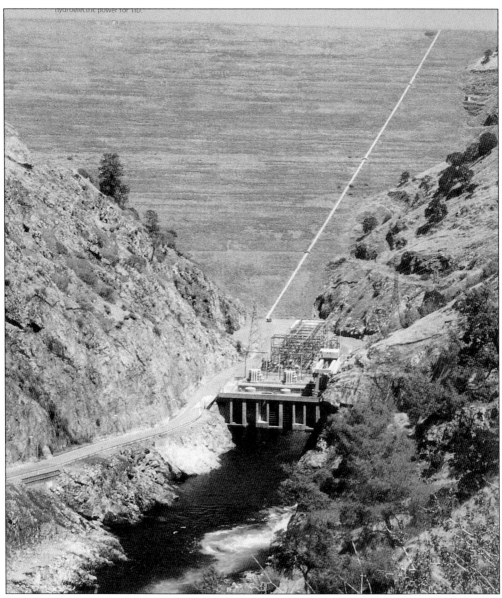

An agreement reached in 1949 between the City and County of San Francisco and the two irrigation districts called for a new reservoir plan upstream as well as a new and larger Don Pedro reservoir. After years of planning, surveying and negotiating a ground breaking was held at the New Don Pedro site on October 6, 1967. The completed earthen-rock fill structure rises 580 feet and the reservoir has a capacity of 2,030,000 acre feet. The hydroelectric power plant can generate about 600 million kilowatt hours of electrical energy each year. (Courtesy Turlock Irrigation District.)

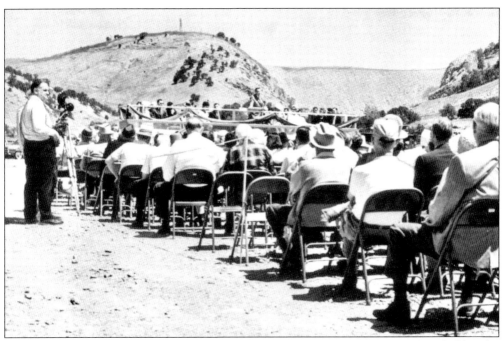

On May 22, 1971, project dedication ceremonies for the new Don Pedro Dam were held at the dam site. San Francisco Mayor Joseph Alioto made the keynote address to the 3,000 guests attending the ceremonies and barbeque. (Courtesy Turlock Irrigation District.)

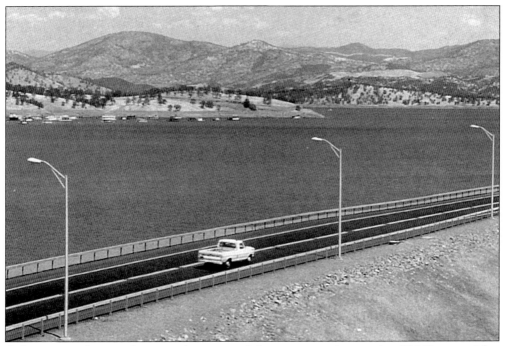

A drive across the new dam provides a view of the vast reservoir, covering 12,960 acres with a shore line of 159 miles. Today, TID is one of only four irrigation districts in the state that serves a dual role as irrigation water and retail power provider. (Courtesy Turlock Irrigation District.)

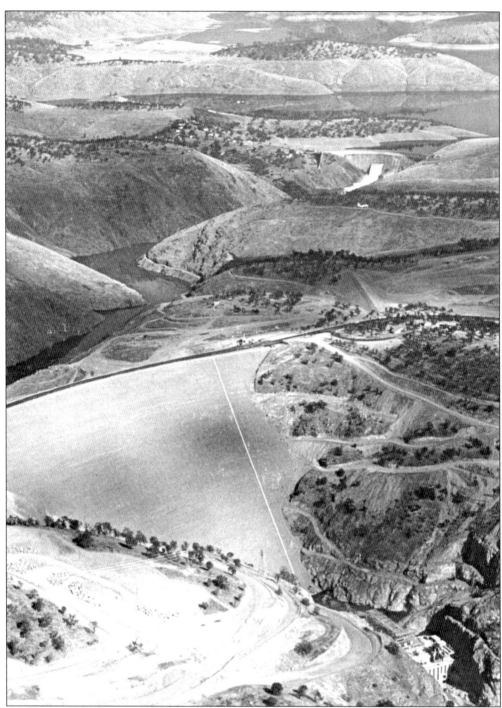

This photo provides one last look at old Don Pedro Dam. On November 2, 1970, the gates on the face of the dam were opened for the last time. Water flowing out of old Don Pedro began to create the new reservoir behind the new Don Pedro Dam. The submerged old Don Pedro is now an underwater monument to the successful "wedding of the land and the water." (Courtesy Turlock Irrigation District.)

Five
INCORPORATION
A NEW BEGINNING

By a vote of 61 to 42, the people of Turlock approved Turlock's incorporation in 1908. The first meeting of the board of trustees (later the city council) was held that same year in the office of the Turlock Land Company. H.E. Blewett (right) was elected president of the board, Turlock's first mayor. Joining him on the board were H.S. Crane, A.G. Elmore, E.B. Osborn, Theodore Olson, and August P. Warren. Within a year the council had addressed sanitation issues, the provision of light and power, construction of a water and sewage system, and pavement of Main Street. (Courtesy Turlock Historical Society.)

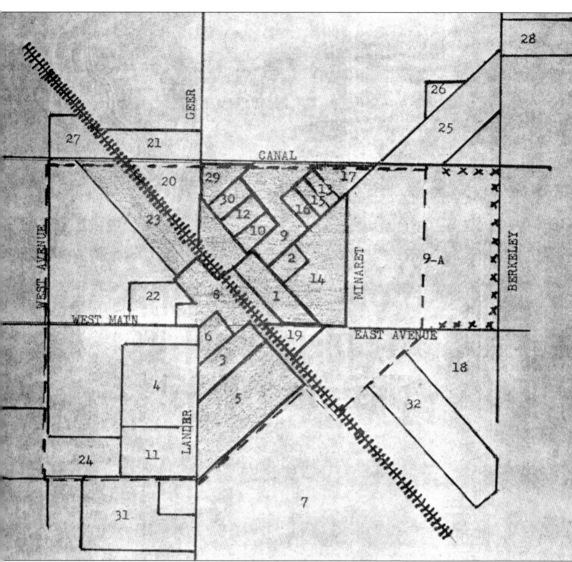

Official city maps in 1911 illustrated the changing face of Turlock's downtown. Early Turlock centered predominately on East and West Main Streets. The town was designed with streets running parallel to the railroad tracks (gray shading). By 1911 Turlock was bounded on the North by Canal Drive, the west by West Avenue, the south by South Avenue, D Street, East Avenue and the East by Bell Street (indicated by the broken line). By 1919 the eastern boundary had been moved to Berkeley Avenue. Large blocks of farmland were subdivided (indicated by the numbers) and housing spread in all directions. As the town expanded streets were laid out in a North-South grid pattern and many of the old road names were changed. Front Street was still used (today's Golden State), but Market became Crane Avenue, Elm (Palm), Diablo (Thor), First Street (Columbia), Second Street (High) Third Street (Castor), another Second Street (Broadway), and a road simply called "Avenue" (Marshall Street). (Courtesy *Turlock Journal*.)

The establishment of Turlock's first fire department preceded the town's incorporation. Local merchants, frustrated by continual fire problems, formed a fire district in 1907 and contributed $100 per person to dig wells and purchase fire equipment. A hose cart and water pumper were purchased and stored inside Osborn's garage. It was later replaced by more modern equipment, including this Ford Model T pumper driven by J.E. Slim Farris. Original fire commissioners included Horace Crane, John Gall, and Martin Hedman. In 1912 the city organized its first volunteer fire department and E.B. Osborn was selected as the fire chief. (Courtesy Turlock Fire Department.)

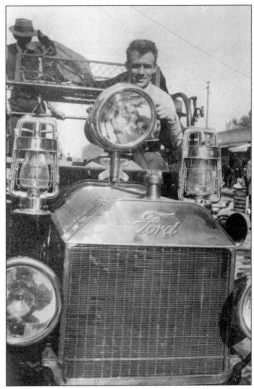

Organized in 1906, the Women's Improvement Club operated until 1942. Their contributions to Turlock included a clean up of the cemetery, establishment of a library, placement of a public drinking fountain, and the construction of Broadway and G.A.R. parks. This photo shows the arbor that was built in Broadway Park. (Courtesy Mike Ermtoed Collection.)

In the 1920s and 1930s Turlock's citizens feared a train stopped at the Turlock depot might block access to one side of the town if there was a fire. To solve this problem two fire engines were positioned on the town's east and west sides. On the west side the engine sat on Locust Street near Hawthorne School and later in the back of Nick's Auto Electric. The east side location was inside the Wakefield Hotel on Front Street (an annex of the Carolyn Hotel). Here some early firefighters undergo an initiation inside that first station. (Courtesy Turlock Fire Department.)

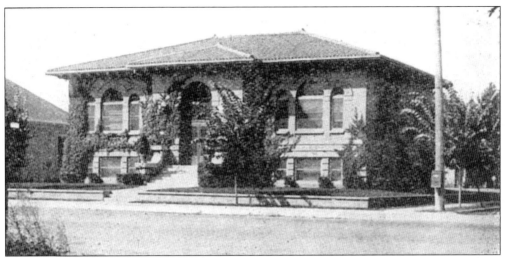

In 1914 the city of Turlock applied for a grant from Andrew Carnegie and received $10,000 for the construction of a library. In 1915 the city purchased property on North Broadway from August Anderson and construction of the library began. The Carnegie Library was completed in 1916 for a total cost of $9,200. (Courtesy Turlock Historical Society.)

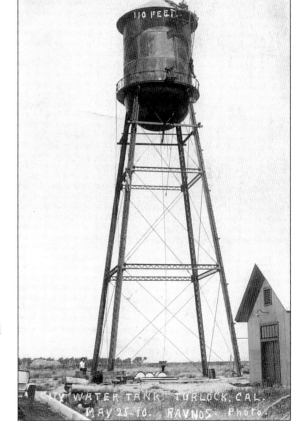

Chicago Bridge and Iron Works was the contractor for the construction of the 110-foot water tank in Turlock. It was built over the city's first well that was located in back of the present Fire Station No. 1 on Minaret. It was added in order to increase the water pressure for the town. Unfortunately, in May 1910, Herschel Carlisle, a Chicago Bridge and Iron Works employee, fell from the scaffolding and died. (Courtesy Turlock Historical Society.)

For a brief four years Turlock had its own junior college. Established in 1917, it was the first junior college in Stanislaus County. Classes were held at the Turlock High School campus. The school closed because of the financial burden placed on the high school. The opening of a junior college in Modesto occurred shortly thereafter. This photo shows the 1918–1919 student body. (Courtesy University Archives CSU Stanislaus.)

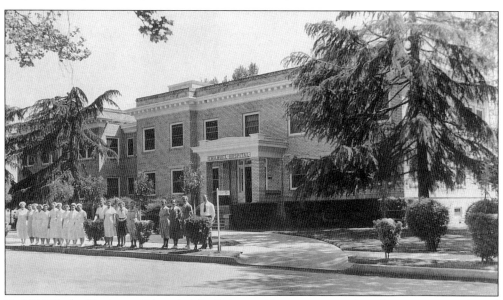

By 1916 Turlock's six small hospital facilities could not accommodate the growing number of doctors in Turlock. In 1917, a new ivory two-story hospital was completed on Canal Drive. Its establishment was due to the vision of four men: Drs. Eric and Albert Julien, and two Swedish Mission pastors, Revs. August G. Delbon and E.N. Train. The pastors were instrumental in securing a sponsorship from the California Evangelical Missionary Association, a regional conference of the Swedish Mission Church. The new medical facility was named Emanuel (God is with us) Hospital. (Courtesy Emanuel Medical Center.)

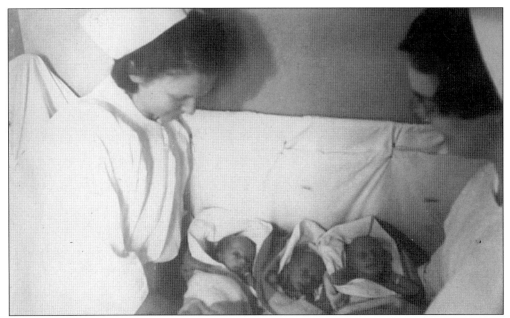

Emanuel Hospital was built to house 34 patients. Room rates were set at $4 to $7 and surgeries ran between $12 to $20. The patient rooms, a main reception area, the kitchen, and an X-ray room occupied the first floor. In addition, two operating rooms, patient rooms and wards occupied the second floor for the surgical patients and the obstetrical department. Pictured here are the Funk triplets, born in 1939. (Courtesy Emanuel Medical Center.)

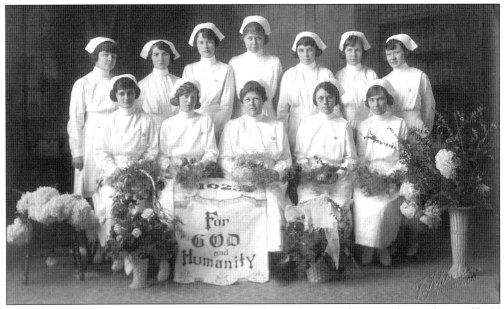

To apply for the school of nursing, a candidate had to be between the ages of 18 and 30 and hold a high school diploma. Candidates also had to provide evidence of physical, mental, and moral fitness. The two-and-a-half-year program included courses in anatomy, chemistry, hygiene and sanitation, and bacteriology. Nurses were required to wear white uniforms and received wages of $8 a month the first year, $10 the second, and $12 the third. (Courtesy Emanuel Medical Center.)

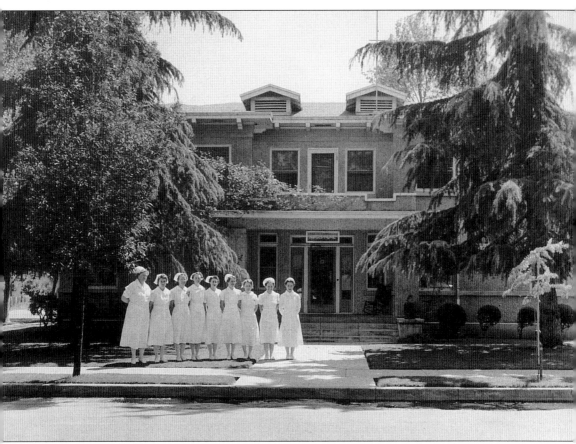

In 1918 the Emanuel Hospital School of Nursing opened with six students. Initially the students were housed in rented rooms, but in 1923 Dr. Albert Julien financed the construction of a two-story building on Oak Street across from the hospital that provided living quarters for up to 16 nurses. The building also included one classroom. In 1935 the nursing program was discontinued and in 1959 the building was moved to the corner of Denair Avenue and Wayside. (Courtesy Emanuel Medical Center.)

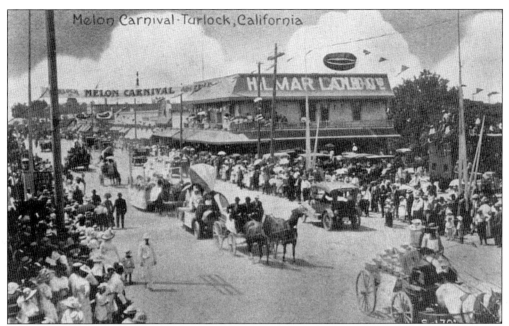

The inaugural year of the Melon Carnival, 1911, marked the only time it was held on Main Street. In August, the festival celebrated the success of Turlock's melon industry. Festivities included concerts, parades, exhibits, dancing, and competitions such as a hose cart race and a 50-mile motorcycle race. The advent of World War I brought a hiatus to the carnival, but it was revived in 1926. In 1934 it became the 38th District fair. (Courtesy Turlock Historical Society.)

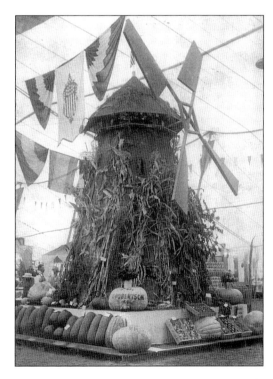

Inside the Melon Carnival's big tent was a stock exhibit, the state Irrigation Convention, exhibits like the one pictured here, and plenty of free melons to eat. (Courtesy Turlock Historical Society.)

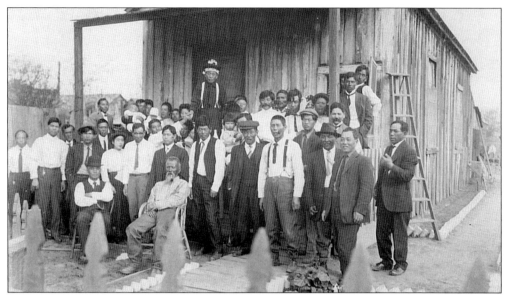

Japanese immigration to the United State began in the second half of the 19th century. Discriminatory practices precluded many from owning land or securing jobs other than as domestic helpers, janitors, laborers, or migratory workers. A large portion of Turlock's Japanese population arrived between 1914 and 1924. There were some early Japanese businesses in Turlock, including a laundry, an Asian food store, a few restaurants, and a pool hall. Under the leadership of Nisaburo Aibara the Stanislaus County Japanese Association was organized. (Courtesy Esther Noda Toyoda Collection.)

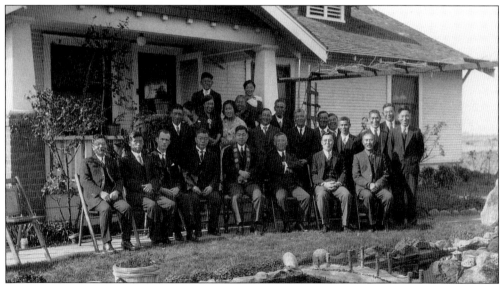

Many of Turlock's Japanese settlers, such as the Toyojiro Tomiye family, started agricultural ventures. After initially raising sweet potatoes and watermelons, cantaloupes became the leading Japanese crop. Organized in 1914, the California Cantaloupe Company was instrumental in leasing land to Japanese farmers and in encouraging the eastern shipment of melons. The Tomiye's, who arrived in Turlock in 1913, eventually purchased this farm on Faith Home Road where they farmed melons and row crops. (Courtesy Esther Noda Toyoda Collection.)

Portuguese settlement in Turlock began around 1901. Many of the settlers were from the Azorean Islands and upon arriving in Turlock purchased land and farmed sweet potatoes the first year. Manuel Pedras exemplified this pattern. He came from the island of Corvo and settled in Turlock in 1902. He planted three and a half acres of sweet potatoes that first year and by 1910 was known as the "Sweet Potato King of Turlock." (Courtesy University Archives CSU Stanislaus.)

One Catholic tradition that was brought to Turlock from the Azorean Islands was the Festival of the Holy Ghost (Espirito Santo). Each Azorean town had a small chapel (imperio) dedicated to the Holy Ghost. The celebration includes a rosary, parade, coronation, dance and feast (traditionally, bread, meat, and wine were given to the poor in honor of Queen Saint Isabel). Turlock's Azorean settlers formed the Pentecost Association in 1912. The first celebration was held in 1913; the Portuguese Hall was built in 1915, and the Chapel in 1921. (Courtesy Mike Ertmoed Collection.)

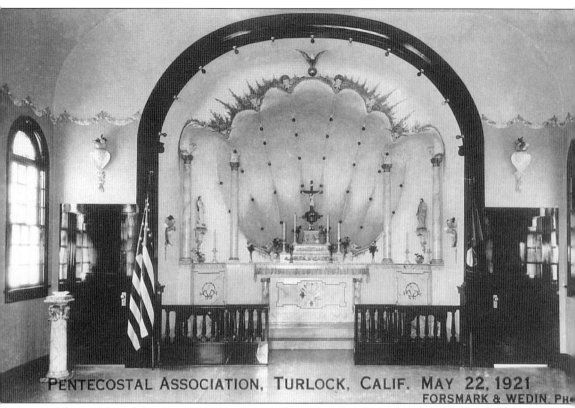

The interior of the Pentecost Association Chapel included an altar framed from behind by a large faux seashell lit with bulbs. A garland of painted roses encircled the room. The traditional symbol of the Holy Ghost—the dove—can be seen above the shell background. (Courtesy Mike Ertmoed Collection.)

(*opposite*) In 1911 Dr. Isaac Adams established an Assyrian colony in Delhi, just outside of Turlock. A native of Persia, he studied as a Christian missionary in the United States and then returned to Persia in order to bring Assyrians to America. After establishing two colonies in Canada, he was persuaded by a colonizing agent from the Santa Fe Railroad to settle near Turlock. He and a group of 45 settlers purchased the land south of Delhi as far as the Merced River and began preparing the land. After a three-day sandstorm struck, all but the Adams and the Hoobyar family chose to return to their former homes. The Evangelical Assyrian Church was organized by Dr. Isaac Adams in 1924 and was located on Minaret and Crane Avenue. Its congregation included a variety of evangelical denominations. It was later moved to this site on Monroe Avenue.

One of Turlock's first permanent Mexican families was Gabriel and Celsa Arrollo who arrived in 1910. Jose Gabriel de la Luz Arrollo Garibay came to the United States after paying an immigration fee of 2¢ and worked on the railroad before returning to Mexico. He and his wife Celsa, along with their first four of ten children, eventually moved to Daggett, California, where Gabriel worked as a section hand for Charles Hohenthal with the Santa Fe Railroad. Upon arriving in Turlock the family first lived on Third Street, then Mitchell, and then Canal Drive. Celsa is pictured here at the Canal address with the wild turkeys she raised. Gabriel retired from Hume Cannery, where he had been in charge of picking up the payroll (in gold and silver) from the bank. The family later changed the spelling of their last name to Arroyo. (Courtesy Marlene Wilson Collection.)

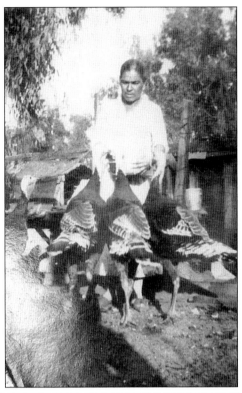

The first Mexican baby to be baptized in Turlock was Maria Jose Luna in 1912. Catholicism was an important aspect of life for many Mexican settlers and Sacred Heart Church provided a place of worship. The first Catholic Church was a small wooden structure built in 1889 on the corner of South Broadway and B Street. This new parish was constructed in 1912 at the corner of Rose and Lyons Streets. (Courtesy Turlock Historical Society.)

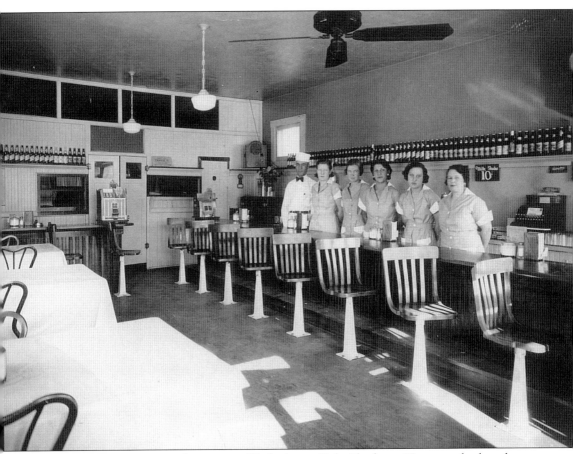

The first Assyrian to open a business in Turlock was Bob Abraham. He opened a hot dog and hamburger stand on West Main Street and Highway 99 (now Golden State Boulevard). By its third year of operation it was so successful that he had to move the business because of heavy traffic. He purchased a lot on Front Street and built Bob's Restaurant. (Courtesy Abraham Family Collection.)

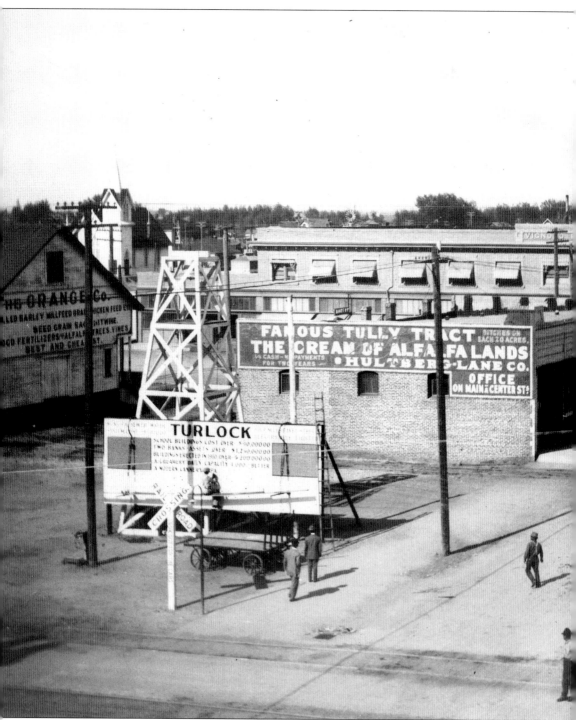

A fierce rivalry developed between Turlock's east and west businesses on Main Street. With the railroad as the dividing line, the two factions fought over the placement of key businesses and public buildings, including the high school, the post office, and theaters. In addition, the east side businesses were willing to serve the Japanese settlers while west side establishments refused.

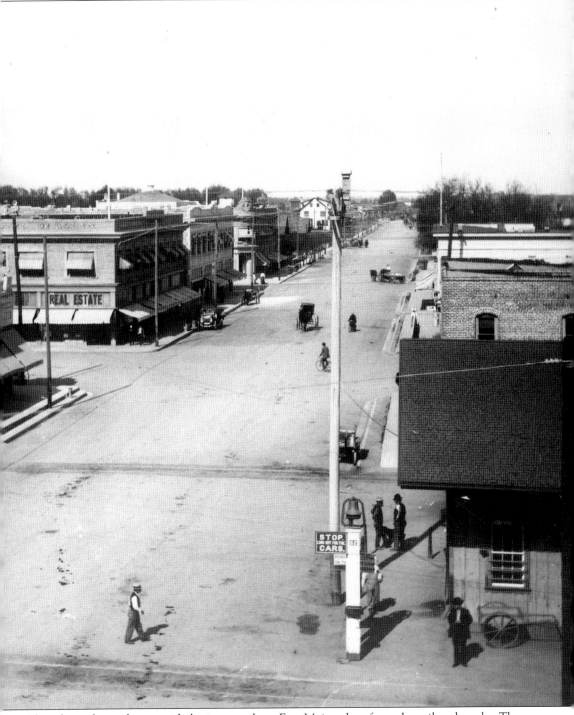

This photo shows the east side businesses along East Main taken from the railroad tracks. The first building on the left behind the Turlock sign is the Hultberg & Lane building. The next building is the old Carolyn Hotel built in 1909, followed by the Geer Building (1910), and the Commercial Bank (1910). On the right is the Southern Pacific depot.

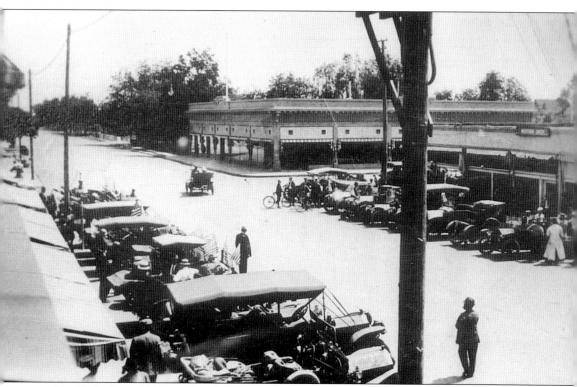

Established in 1911 on South Center Street, the Johnson-Marston Mercantile Company occupied the Chatom building for a short while before moving across the street. Anything a person needed for the home could be purchased at this store. In addition, the company was a dealer for Reo trucks and cars. They later bought out the Turlock Garage that was further down the street. In 1912 the business was sold to Osborn & Son. Initially the Osborn's hoped to manage both this store as well as their original store on Turlock's west side. However, the west side store eventually closed. (Courtesy Robert Brown Collection.)

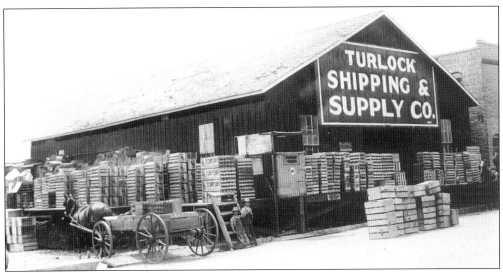

O.G. Olson was another Swedish settler who came to Turlock with his family from Wisconsin in 1908. He built this melon shed on Front Street where Central Park is today. The business was called the Turlock Shipping and Supply Company and he managed it until 1917 when he became an independent shipper. In 1923 his son, Milton, joined the business and acquired the nickname, "Honeydew King" because of their nationally famous honeydews shipped to New York. At the time Front Street served as the town's melon market and daily farmers brought loads of melons to the market to be bid on by individual buyers. (Courtesy Robert Brown Collection.)

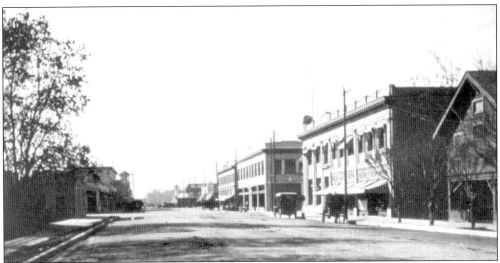

This photo was taken facing west on East Main Street looking towards the railroad tracks in 1910. On the right was the Commercial Bank building, next to it the Geer building, and next to that the Carolyn Hotel. On the left is a grove of trees, and nestled in the back of that grove was the Hultberg boarding house. The following year the second Osborn & Son store opened on Center and Main Street (just down from the Hultberg boarding house). (Courtesy Turlock Irrigation District.)

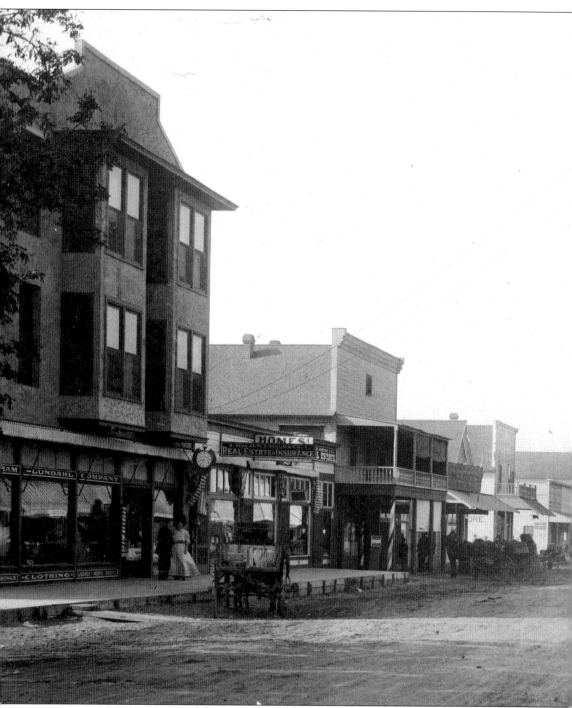

Prior to 1902 much of the city's commercial property was centered east of the railroad line. However, the growing number of settlers in Turlock changed that pattern. Beginning in 1902 commercial buildings began to appear on the west side of the tracks, starting at First Street and continuing west to Lander Avenue. This photo, take from the railroad tracks and looking west on Main Street shows the St. Elmo Hotel on the left and the Osborn building on the right. The

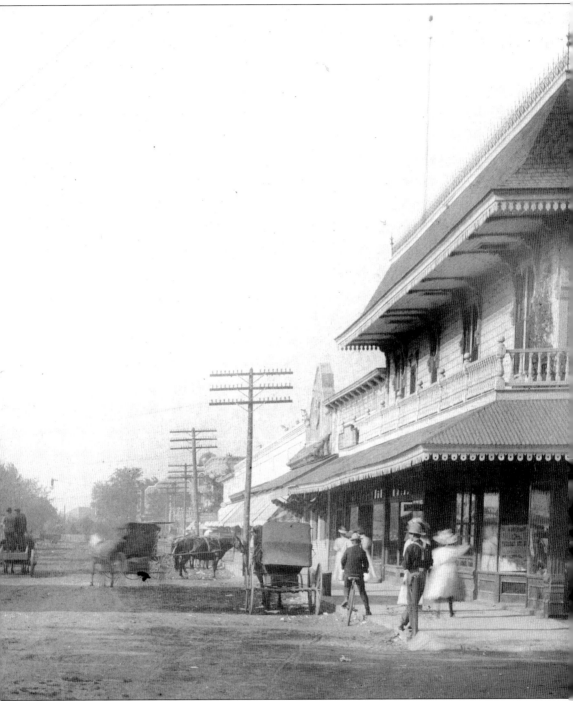

Osborn & Son store originally operated as the Gaddis and Reilly general store. It was the home of Turlock's first telephone in 1898. Henry Osborn purchased the building in 1899. In 1902 the first telephone exchange was installed in the Benjamin W. Child real estate and insurance office, which sat at the back of the general store. (Courtesy Mike Ertmoed Collection.)

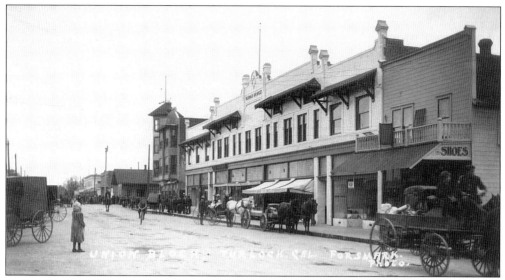

Union Block (right, center) sat between Broadway and South First Streets. Built in 1910 the two-story building was built by Alonzo McGill, who had the majority of the ownership. He had two additional partners—one was Detlof Sahlberg, who owned the wooden building at the west end of the block that housed his shoe store. Some of the early occupants of the Union Block building were the Piggley Wiggley Market, Goodman's Candies-Stationery (later Lee Brothers Stationery), a bakery, and Freitas' Butcher Shop. Sandwiched between the Union Block and the St. Elmo Hotel were a small building that served as a barbershop, and the Wigwam Restaurant. (Courtesy Robert Brown Collection.)

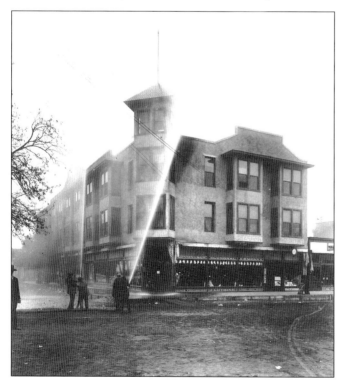

This photo, taken in 1909 shows the Turlock Fire Department testing its new Howe Cylinder pumper. The hotel was built in 1908 on the site of the Fountain Hotel at the corner of Main and South First Street. From 1914 to 1918 the office of the city Board of Trustees was located inside the hotel building. Next to the city offices was C.V. Lundahl's clothing and jewelry store that occupied the corner space. (Courtesy Turlock Fire Department.)

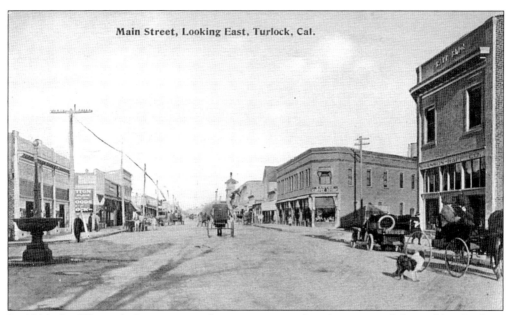

In 1911 the Women's Improvement League oversaw the placement of this public drinking fountain at the intersection of Lander Avenue and West Main Street. This view of West Main Street from Lander Avenue is one of the most photographed intersections in Turlock. (Courtesy Turlock Historical Society.)

Most of the early settlers built homes west of the railroad tracks. Some of the more wealthy citizens built their homes on North Broadway and West Main Street. This photo provides a view of North Broadway. The home directly on the left is the Tom Gaddis home. (Courtesy Turlock Historical Society.)

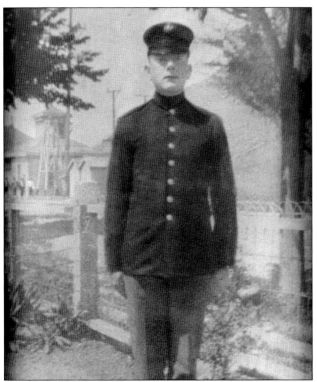

In 1920 the local post No. 88 of the American Legion permanently changed the post name to the Rex Ish Post No. 88. Rex Whitfield Ish was a Keyes native who moved to Palo Alto in 1904, went to Stanford and moved to Turlock in 1914. He worked as the furniture department manager at Osborn & Son. Ish enlisted in the Marine Corps and became a sergeant with the Fifth Regiment's Second Division. Sgt. Ish died on June 23, 1918, while leading an attack on a German machine gun nest at the battle of Bois de Belleau, France. (Courtesy Scott Atherton Collection.)

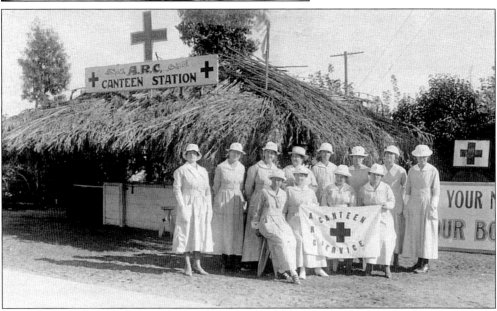

The Turlock branch of the A.R.C. Canteen Service was organized in July 1918, by Cora J. Abbott, chairwoman of the local chapter of the Red Cross. The first station, pictured here, was a primitive shelter made of bamboo. It was the only canteen in the Pacific Division that was entirely self-sufficient, due to generous donations of local farmers and the sale of influenza masks. During its ten months of operation, approximately 30,500 service men were fed and encouraged as they passed through Turlock. (Courtesy Turlock Historical Society.)

Six
THE TIME BETWEEN THE WARS

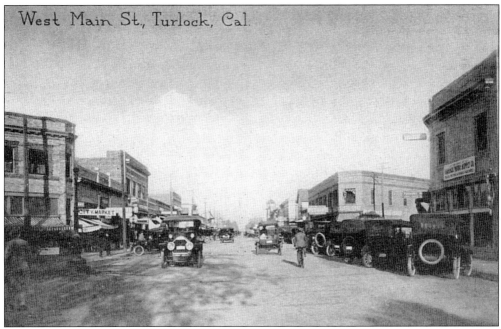

Between 1920 and 1939 much of what happened in Turlock was a reflection of what was happening across the United States. The Depression, Prohibition, electricity, and the automobile all impacted the town. The general store was on the way out, being replaced by specialty shops. This inter-war period marked a change in agricultural practices as farms got smaller and crops diversified. Grapes, peaches, and poultry began to dominate Turlock's agriculture. Locally, the political east-west competition erupted over the location of a new high school and the state highway. (Courtesy Turlock Historical Society.)

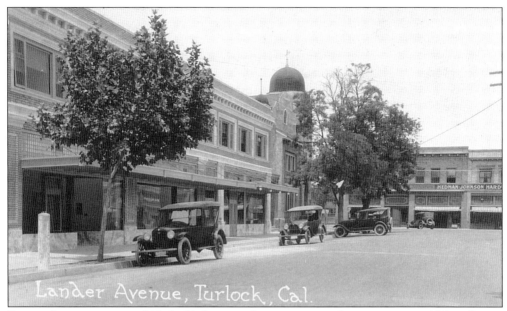

During the interwar period Turlock's business district continued to center around Main Street. This photo depicts the 100 block of Lander Avenue, just off West Main. The building on the left was the Security Hotel and Security State Bank from 1922 to the mid 1930s. The large dome is the old Swedish Mission Church. The buildings at the end of the street include a print shop, flower shop, radio repair shop, a paint store, barbershop, and the Hedman-Johnson Hardware seen on the right. (Courtesy Mike Ertmoed Collection.)

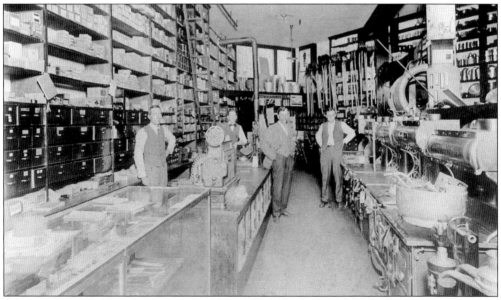

By 1920 farm implements were dropped from the inventory of Turlock's three big general stores—Berg's, Osborn's, and the Mercantile. This photo taken inside the Hedman-Johnson Hardware shows the updated, specialized inventory. Stoves line the right wall, shovels and rakes hang along the back wall, and paint cans fill the cabinets behind the ladder. (Courtesy Turlock Historical Society.)

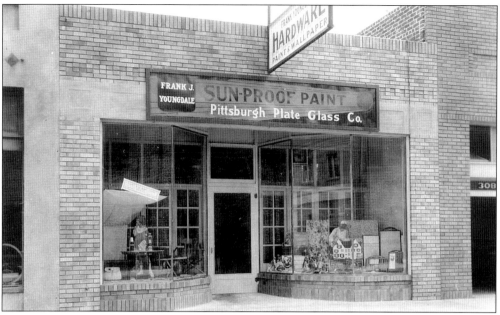

Frank J. Youngdale Hardware opened in the early 1920s on Lander Avenue. A year later it moved to its present location on Market Avenue. As the demand for electrical appliances increased, Youngdale's expanded its appliance inventory. As sales increased, several adjacent buildings were purchased over the years and added to the original store. (Courtesy Mike Ertmoed Collection.)

By 1920 the Berg General Store was something of an institution in Turlock. M.M. Berg was born in Sweden, immigrated to the United States in 1882, and arrived in Turlock in 1903. Berg opened a general merchandise store built on what is now the northeast corner of West Main and Broadway, and sold everything from groceries to buggies to farm implements. In 1912 the small wooden structure was replaced with this new brick building complete with nine offices and a six room flat upstairs. In 1922 the store was sold to the J.C. Penney Company. (Courtesy Turlock Historical Society.)

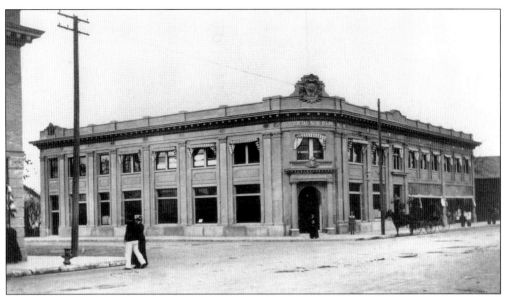

The Commercial Bank of Turlock (known in 1905 as the First National Bank) built a new building at East Main and Center Streets. The $75,000 two-story, brick building with extensive use of marble housed the bank, two retail shops, several offices, and a hall. In 1914 the Commercial Bank was sold to two brothers, Howard and T.B. Whipple, and under their leadership a national charter was obtained and the bank became known as the First National Bank of Turlock. The Whipples sold the bank to Bank of America in 1928. (Courtesy Turlock Historical Society.)

The California Theater opened in July 1920 after a year of construction under the supervision of John F. Knapp. The theater featured silent movies, vaudeville acts, and local entertainment. It was the east side's response to the Turlock Theater, which was built that same year on Turlock's west side by Dick Arakelian. The California was purported to be the most modern, best air-conditioned, most artistically decorated structure in Turlock, including a Wurlitzer pipe organ. In later years its name changed to the Fox Theater and ultimately the building became a bowling alley. (Courtesy Robert Brown Collection.)

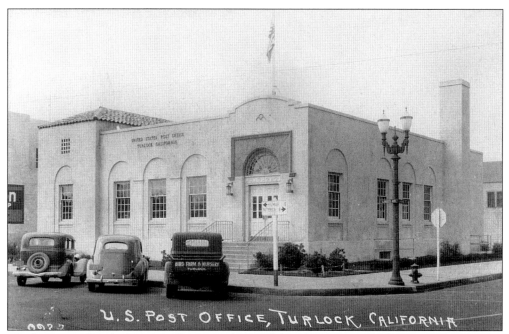

The location of Turlock's post office caused great debate between Turlock's east and west sides. In 1935 the west side won the battle when a new building was constructed on the corner of West Main and Lander. However the east side eventually won the post office war when the post office was moved in 1966 to 555 East Main, its present location. (Courtesy Mike Ertmoed Collection.)

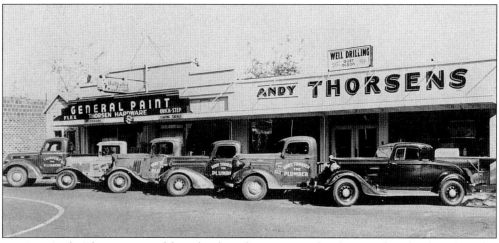

In 1911 Andy Thorsen started his plumbing business, Andy Thorsen the Plumber, from his home on High Street. In the early years he was known to travel to job sites on bicycle with a pipe on his shoulder. In 1917 he built a shop at 214 Lander Avenue and soon after he became one of the first businesses to utilize a car—a Model T Ford—in his work. Around 1930 he moved to 134 Lander Avenue and in 1941 changed the name to Thorsens as his son joined the business. (Courtesy Turlock Historical Society.)

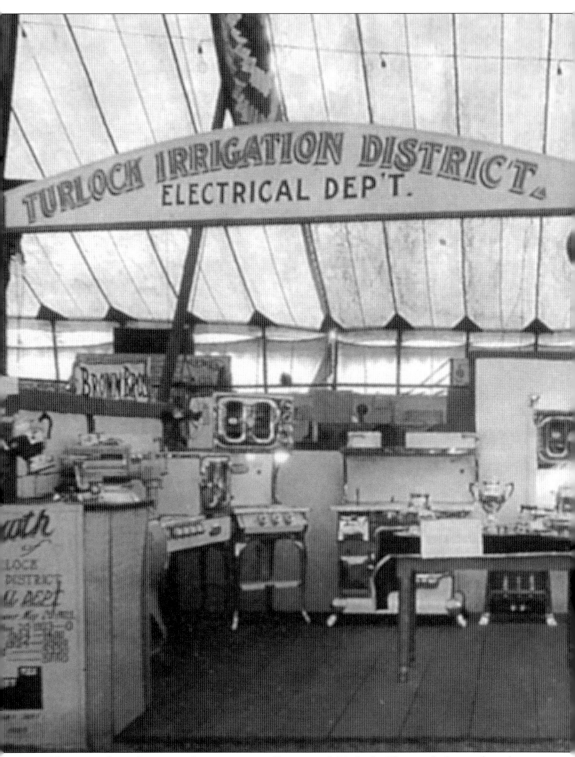
Electricity brought many changes, especially to rural Turlock. Electric lights and appliances replaced wood burning stoves and gas lamps. In 1923 the TID opened its own appliance store

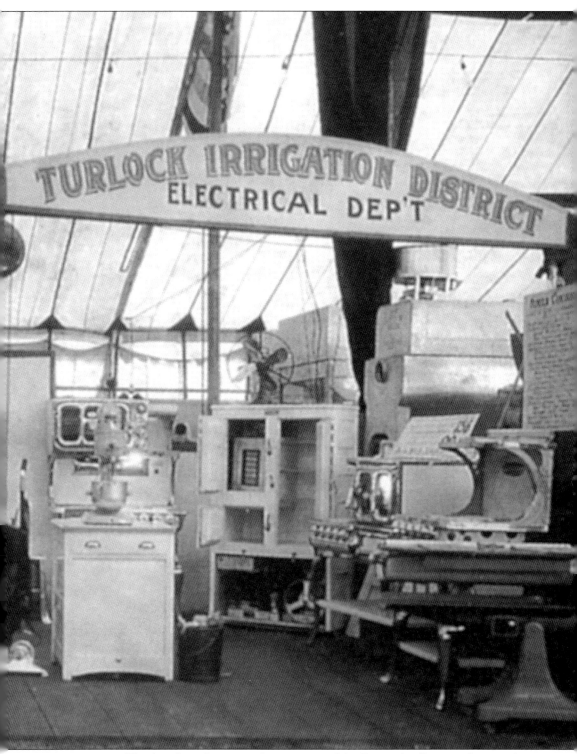
to increase usage. This booth at the county fair was part of the District's efforts to advertise the availability and uses of electric energy. (Courtesy Turlock Irrigation District.)

By 1910 Turlock High School's west side location was overcrowded. The proposed construction of a new high school again fueled the east–west debate. Two sites were proposed—one on Lander Avenue and the other on what would become Canal Drive. In the end the east side won out and the new school was designed in 1919 by architect H.W. Wells of Stockton and contracted by O.C. Holt of Hilmar. The east wing was completed in 1920. (Courtesy Robert Brown Collection.)

The new high school was built gradually and paid for out of the district's current revenues. Students attended some classes in the east wing and then returned to the old campus for their other courses. The fall of 1926 was the first year all Turlock High School classes were held at the newly completed campus on Canal Drive. (Courtesy Turlock Historical Society.)

The senior class of 1927 added to the funds collected by previous senior classes to place a fountain in front of the main entrance to the high school. The statuary and fountain were designed by Thomas Moscato, class of 1929, under the supervision of the art department and Miss Viola Siebe. Commendation was given to the students for the beautiful gift, which stood about six feet high with a pool at its base. (Courtesy Robert Brown Collection.)

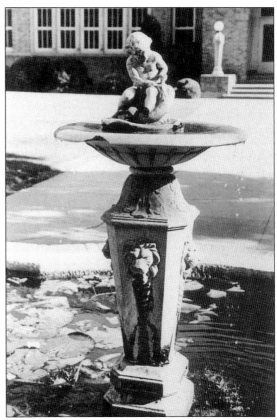

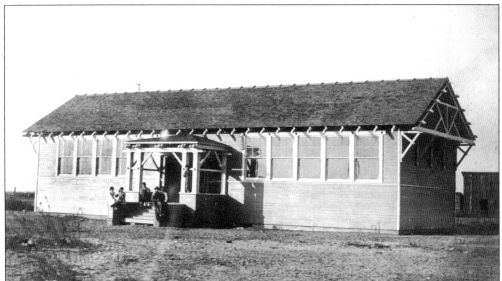

The old Tiger's Den at Turlock High School, used in the 1930s and 1940s, was named for Armand (Tiger) Seghetti, a football coach at the high school. His nickname came from his time as a lineman with the St. Mary's College football team. The building was once a study hall supervised by Seghetti. In 1958 it was purchased by Turlock Community Players and was to be used as a clubhouse at a new site. (Courtesy Robert Brown Collection.)

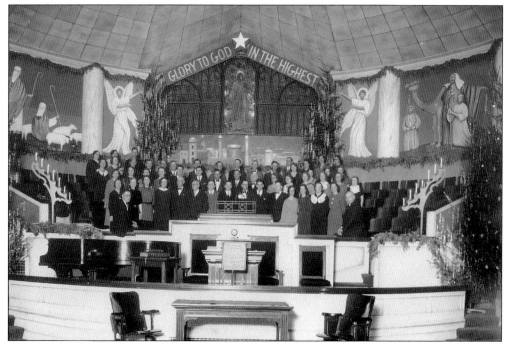

In 1923 the Swedish Evangelical Mission Church was looking for a new site and purchased the old high school grounds at Locust and High Street for a cost of $15,500. It was renamed Beulah Covenant Church. This photo was taken inside Beulah during a Christmas celebration held in 1934. The Reverend Walfred Westlind painted the murals. The director of the choir was Emil Wallstrom. In 1963 the original building was torn down and replaced. (Courtesy Emanuel Medical Center.)

The St. John's Assyrian Presbyterian Church was established in 1926 on Palm and Minaret. Dr. Elisha David worked for the church's establishment and then served as its pastor until 1956. Pictured is the Assyrian Presbyterian Ladies Aid. (Courtesy University Archives CSU Stanislaus.)

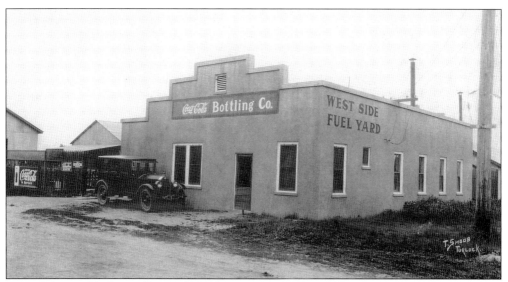

One of the world's best selling soft drinks was once made and bottled in Turlock. The Coca-Cola Bottling Company began as Turlock Soda Works in 1910 and was located at 520 "B" Street. John Lunden was the original owner and he bottled soda water and sarsaparilla. In 1913 he sold out to Albert Sollars and a partner. In 1920 Sollars obtained the Orange Crush franchise. He sold out in the early 1920s to E.C. Utendorffer and two other partners. In 1925 Utendorffer became the sole owner and a year later won the Coca-Cola franchise. He immediately changed the company's name to reflect the new franchise and for the next ten years Coca-Cola was made and bottled in Turlock. (Courtesy Mike Ertmoed Collection.)

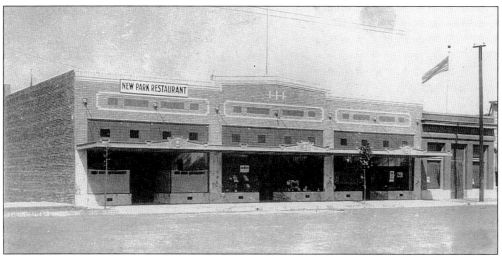

During the interwar period numerous small businesses were opened in Turlock, including restaurants. The New Park Restaurant was one of over eight Greek restaurants operating in Turlock by 1930. Located at 115 South Front Street, it was purchased in 1919 by four partners: Nick Pantazopulous, Peter Karabinis, Earnest Docolos, and Robert Perdatos. They enlarged the serving area, installed a 24-seat lunch counter and added seven to eight shiny new booths. It reopened in mid-January, 1920, and was open 24-hours-a-day. Other Greek restaurants included the Oyster Loaf Café, California Café, Carolyn Café, Yale Café, Orpheum Grill, Melon City Café, and the Turlock Restaurant. (Courtesy Turlock Historical Society.)

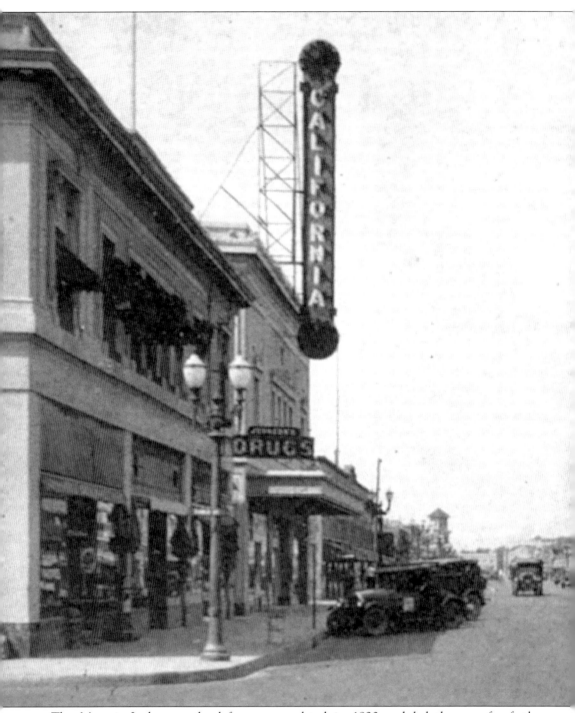

The Masonic Lodge, on the left, was completed in 1920 and led the way for further development to the east. In 1921, Herbert Clougher purchased four lots on the northwest corner of East Main and Thor to erect a companion building to the Masonic Lodge across the street. This new Sierra building, on the right, was completed in June 1922 with Villinger Stationery, Turlock Furniture, Nigh's Cash Grocery (which later became Espindola's), and Dr.

Folendorf as first tenants. From 1923–1925 the upstairs was occupied by the Lillian Collins Hospital, and in 1927 Drs. Eric and Albert Julien purchased the building and occupied the upstairs. Today the restored Sierra building is home to Endsley & Associates/Coldwell Banker Real Estate and the Silk Flower. (Courtesy Turlock Irrigation District.)

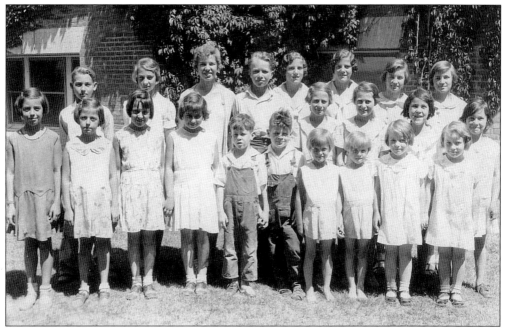

In 1932 eleven sets of twins were enrolled in Turlock's two grammar schools, Hawthorne and Lowell. Eleven pairs of twins out of 1,100 pupils may have been something of a record. This Forsmark photo captured all eleven pairs, who are identified from left to right: (front row) Jane and Jean Pope, 6 years old, and Wanda and Oleta Lewis, 8; (second row) Edna and Bessie Dokolas, 9, Hazel and Helen Jorge, 10, Thomas and Richard McCue, 6, Floreen and Nora Hauser, 12, Aileen and Elaine Coltharp, 9; (back row) Paul and Pauline Thorpe, 12, Eva and Maynard Fosberg, 12, Edith and Ethel Hatfield, 10, Lorelei and Lorraine Hallstone, 13. (Courtesy Turlock Historical Society.)

The Divanian family arrived in Turlock in 1920 and joined Turlock's growing Armenian population (The first three Armenian families had arrived in 1915). In 1934 the Divine Gardens Restaurant opened near the old Highway 99. It included an outside dining area within a garden setting. Known for its excellent shish kabob and nighttime dancing, the restaurant was a success. This picture captures the garden area of the restaurant. (Courtesy Turlock Historical Society.)

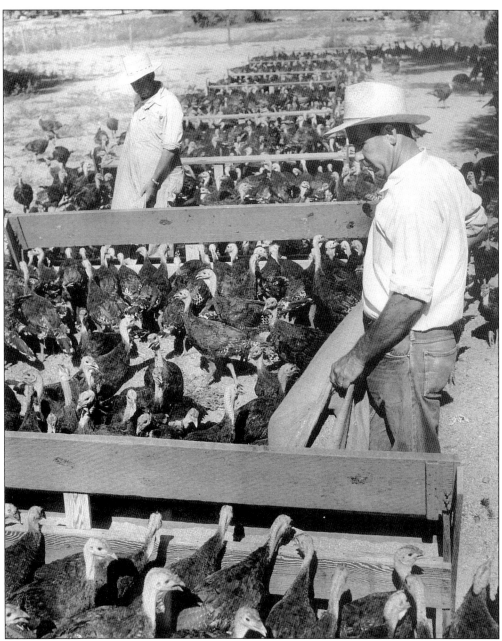

One of the area's first turkey farmers was Pat Rapp, who began turkey farming around 1925. Other turkey farmers soon began to join Rapp. In Turlock, the Conyers Brothers (pictured above) were established in 1928 on Linwood Avenue. Turkey farming was very different back then. Independent turkey farmers, not large corporations, dominated the industry. Flock sizes were small and the farmer managed all aspects of the business—from breeding and hatching to processing and sales. Antibiotics were not available so disease was always a danger. The turkey itself was also different. Turkeys' feathers were mostly bronze and the turkeys were smaller, leaner and rangier. (Courtesy Ray Conyers Collection.)

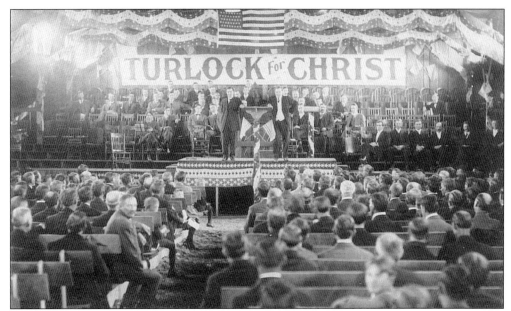

In 1930 a Ripley's "Believe it or Not" cartoon featured the city of Turlock. The town was cited for having more churches per capita than any other town in the United States. Most of the town's churches had been established prior to World War I and the era between the wars was characterized by two religious patterns: the growth of Assyrian churches, and the development of Sunday schools—both Mitchell Community Church and the Mountain View Community Church were established by the American Sunday School Union. This photograph depicts one of the many revivals that came through Turlock. (Courtesy Turlock Historical Society.)

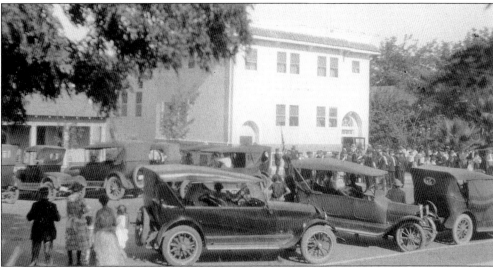

This familiar building on North Center Street was originally built for the Salvation Army in the 1920s. The basement included a social hall, kitchen, and two classrooms. A main hall, ladies parlor, and office occupied the first floor while the second floor was a five-room apartment to be used by the officers. The Rex Ish Post acquired the property in the 1930s and it remained the American Legion Hall for many years. In the 1980s the building was renovated for the Heritage Restaurant and later became the El Antojito Restaurant. (Courtesy Turlock Historical Society.)

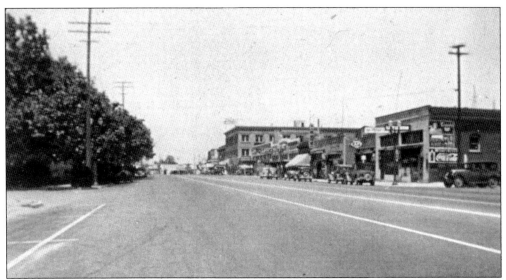

The location of the early state highway caused great consternation between the east and west sides. Around 1910 the first official route was established along the Southern Pacific railroad tracks (now Front Street), and over the years it was rerouted to Broadway and then to Center Street. In 1931 growing traffic congestion and the need for jobs during the Depression led the Chamber of Commerce to propose rerouting the highway yet again. For one year the highway was divided with northbound traffic on Center Street and southbound traffic on Broadway. The 1934 city council election centered on this issue with sides divided over the three routes; Center, Broadway, and Front. The Front Street proponents won the election and the highway was rerouted to the street pictured above. (Courtesy Turlock Irrigation District.)

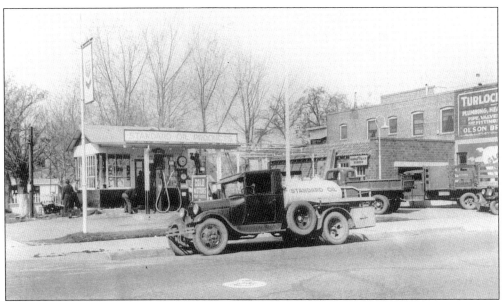

Gone were the days of the livery and blacksmith. The public's automobile needs were met in Turlock with numerous garages for repairs, auto dealers for sales, oil companies serving the industrial and agricultural customers and gas stations like this one at Lander and Columbia. (Courtesy Turlock Historical Society.)

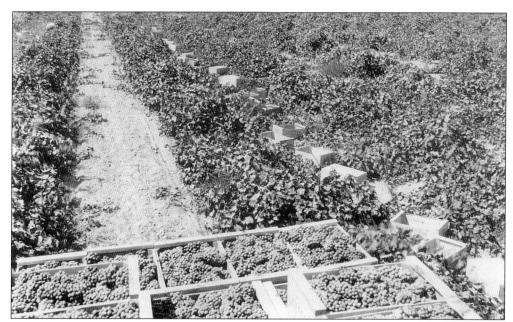

In the 1920s the grape and peach industry were taking hold. Prior to 1921 wine grapes were the primary variety grown in the Turlock area. However, the advent of Prohibition made fresh grapes and raisins a hot commodity. Peaches became a second fruit crop that gained popularity in Turlock during the inter-war period. (Courtesy Turlock Historical Society.)

The rise of fruit crops such as peaches, pears, and apricots increased the need for local canneries. During the 1930s the Hume Canneries provided employment, (as well as housing in some cases) to 400 men and women. The Puccinelli Packing Company survived the Depression through the development of dehydrating processes and equipment. A cooperative that later became Tri-Valley was started and Calpack (later Del Monte) began shipping from Turlock to the east bay. In the 1940s the principle buyers and shippers of fruit were A.T.B. and Turlock Fruit Company. (Courtesy Turlock Historical Society.)

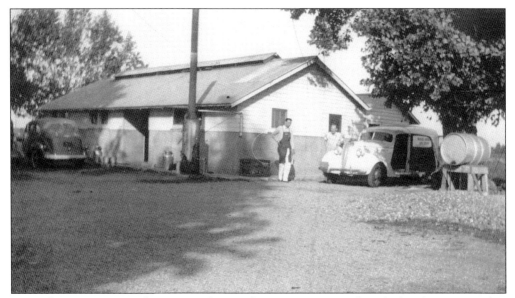

Dairy farming continued to grow during the inter-war period and the Azorean settlers controlled more than 50 percent of the milk production in the valley. The dairy industry was hard hit by the Depression and milk prices plummeted. As a result the industry supported a move to establish pricing and marketing controls to avoid such problems in the future. Also, the creamery industry began to consolidate as trucks allowed milk to be hauled greater distances. (Courtesy Turlock Historical Society.)

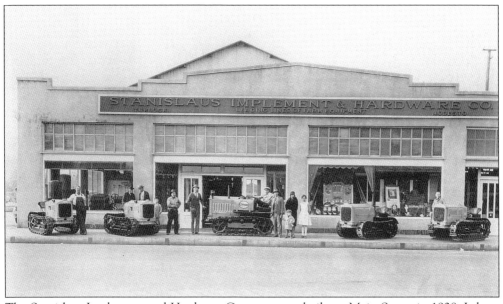

The Stanislaus Implement and Hardware Company was built on Main Street in 1928. It later became Don Pedro Hardware, then Turner Hardware, and eventually Woods Furniture. (Courtesy Turlock Historical Society.)

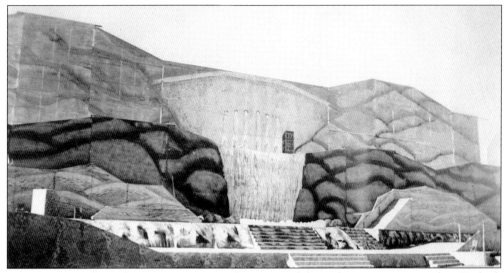

In 1937, 50 years after its inception, the TID celebrated its impact on the Turlock landscape. To mark this event a 60-foot replica of Don Pedro Dam was constructed at the Turlock High football field. Fireworks flowed down the structure to depict water cascading over the dam. At the Jubilee, California's governor made an address that was followed by a parade, picnic supper, and vaudeville shows.

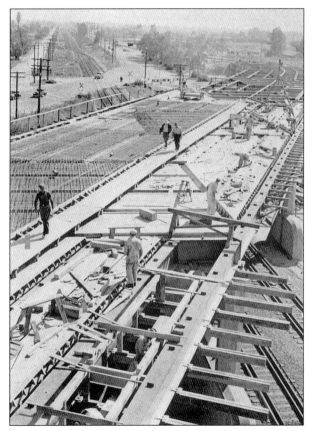

In the November 1939 issue of *California Highways and Public Works*, it was reported that the Turlock overhead project was 75 percent completed and that one of the few remaining dangerous grade crossings would soon be eliminated. The article was referring to the overpass on Golden State Boulevard south of town. In 1913 a 90 degree crossing over the Southern Pacific tracks was surfaced with sharp approach curves. In 1934 it was modified, but still considered dangerous because of the heavy traffic of 5,600 vehicles passing over every 16 hours. The new overpass was 1,247 feet long with a 23 foot clearance for the trains and was considered an economical and innovative design. (Courtesy California Department of Transportation.)

Seven
UNITING FOR VICTORY

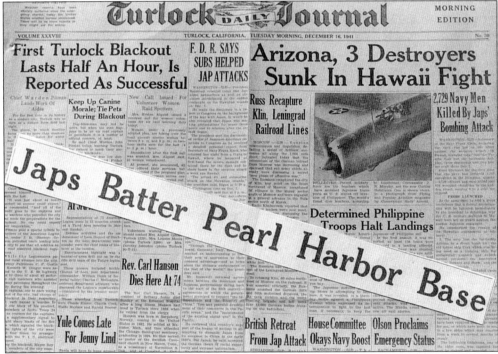

These headlines seen in every newspaper across America shocked people into action. Americans began to rally for the defense of the United States, its spirit of freedom, and its way of life. After surviving the Depression a short period of optimism followed. Then Hitler's aggressive actions in Europe, controversy over Lend-Lease policies, and other world affairs kept the threat of war on Americans' minds. After December 7, 1941, a *Turlock Journal* editorial commented that the American people should unite on a single purpose: to make the sacrifices at home in order to support the military effort to "wipe axis dictatorships off this earth." The war years changed every aspect of American life, both physically and emotionally, and overshadowed other events of the decade. (Courtesy *Turlock Journal*.)

Under fear of attack, aircraft warning posts were set up in towns up and down California. The Turlock post was at the TID yard on North Broadway, and Chief Observer H.M. Wallin began to train volunteers on December 11, 1941. Turlock women staffed the post with the help of 24 Turlock High School students who were members of the Community Service Division of the Victory Corps. (Courtesy Turlock Irrigation District.)

During World War II, citizens' ears were tuned to the radio and their eyes to the newspaper. This column heading in the *Turlock Journal* offered news about neighbors, friends, and loved ones for local residents. The population of Turlock in 1940 was listed as 4,839. This small size allowed Turlock citizens to have a close community. Citizens shared the burdens of the worry and sorrow along with the joy of good news together. (Courtesy *Turlock Journal*.)

John Pitman was made Chief Warden as defense plans were organized in January 1942. Turlock had ten defense zones (the election precinct zones), each zone with a Captain. The Defense Wardens enforced Pacific Coast Proclamation #10, the "Dimout Order." Along the coast from Canada to Mexico and 150 miles inland outside lights and signs were shut off and industrial lights and traffic signals were dimmed. (Courtesy Turlock High School.)

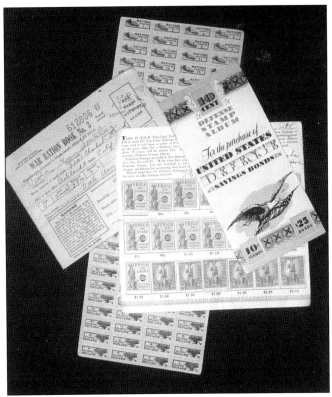

When the Defense Stamp Album, shown here, was filled it had a value of $18.75 and could be exchanged for a Defense Savings Bond worth $25.00 in ten years. On the back of the War Ration Book it said that rationing was a vital part of the country's war effort and reminded citizens, "If you don't need it, Don't buy it." Meat, fat, sugar, coffee, butter, eggs, cheese, shoes, metal appliances, and gasoline were all rationed. Allotments were set for tires and retreads. While servicemen ate powdered eggs, Spam, and rations, women at home created recipes for "War-Time Cake" that was eggless, milkless, and butterless.

105

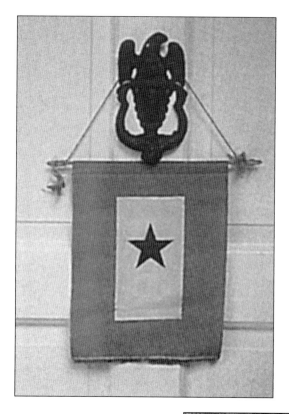

Beginning in World War I and continuing in World War II a Service Flag displayed in windows had a blue star for each family member in military service. In 1918 President Woodrow Wilson approved the use of a gold star to be displayed for each service member who had died. The gold star was to represent the family's pride and devotion for the service man or woman who had made the supreme sacrifice for the country.

The Gold Star Mothers organization, established nationally in 1928, was started by Grace Darling Siebold after losing her son. The organization continues today serving the country by offering comfort to mothers, assisting hospitalized veterans and their families, and by displaying patriotism. The U.S. Congressional Resolution of 1936 designates the last Sunday in September as Gold Star Mother's Day. Mrs. Mary Ella Switzer of 640 South Center Street had five sons in the service and became a Gold Star Mother when Alfred and Raymond were killed while serving their country during World War II. (Courtesy *Turlock Journal*.)

V Mail, developed by the U.S. Government, began with an 8-and-a-half-by-11-inch sheet of paper with address information and the serviceman's message. The letter was then posted, censored, microfilmed, and reduced in size to save cargo space. In this V Mail, Al Sonntag attached the New Year's commissary menu with his greeting. Civilian mail was also subject to censorship. This envelope shows (at the end) that it was opened and read by "Military Censorship—Civil Mails." The cancellation mark says "Buy U.S. Savings Bonds."

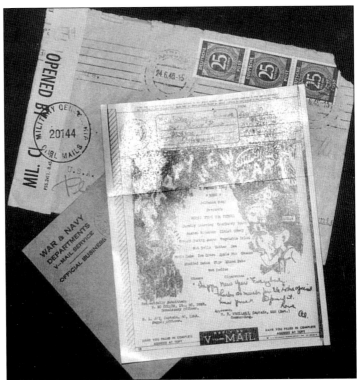

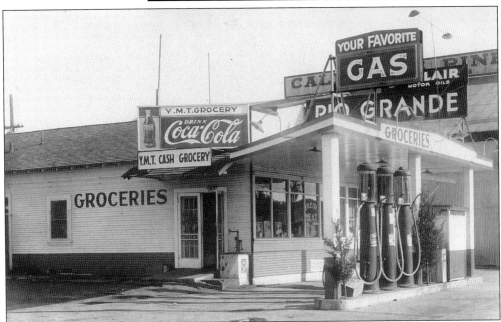

The Y.M.T. Grocery, named for the Yokoi daughters, Yae, Misa, and Teru, opened in 1927 at East Avenue and Center Street. In 1934 the store moved to East Avenue and Highway 99. It was a meeting spot for Japanese-American farmers and town residents who traded at the store. When the Yokoi family received restrictive orders, the store was sold to Henry Parker of Vernalis. (Courtesy Esther Noda Toyoda Collection.)

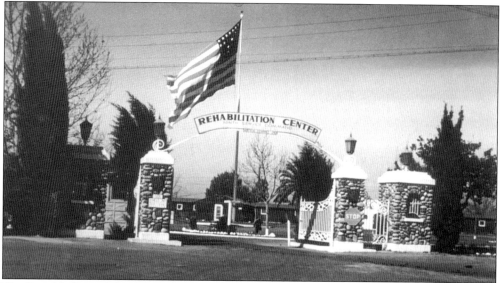

The Rex Ish Post of the American Legion dedicated the Legion Field Arch on Memorial Day 1930. The athletic fields and carnival grounds at Broadway and Canal became the new home of the Melon Carnival and later, the 38th District Fair. The fair was suspended during the war years and in 1942 workers erected scores of buildings in three weeks time. The site was first used as the assembly center for Japanese on their way to relocation centers and shortly thereafter became the Rehabilitation Center. (Courtesy Turlock Historical Society.)

In the previous photo the gate reads "Rehabilitation Center" because from 1942 to 1945 the fairgrounds was one of nine U.S. Army prison centers in the country. This photo shows some of the center's employees. Edna McMurphy, fifth from the left in the second row, worked as the Secretary to Col. Ernest Kindervater. It is reported that there were four large barracks, an administration building, hospital, bath houses, latrines, and a Victory garden. One camp worker stated that the commissary and church building remain today as exhibit buildings at the fairgrounds. (Courtesy Edna McMurphy Collection.)

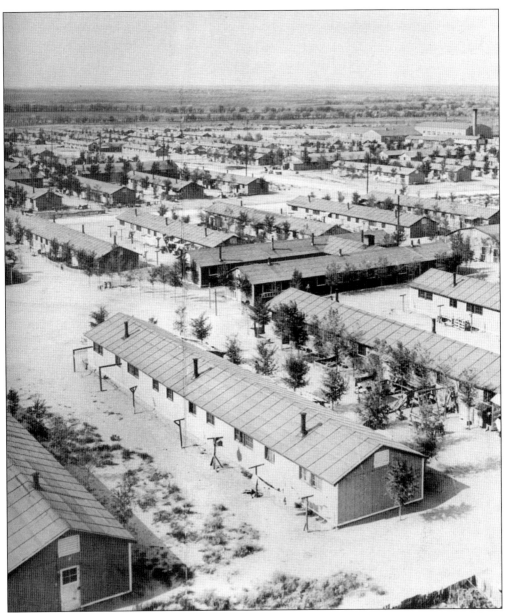

On March 4, 1942, the U.S. government ordered all Japanese citizens and aliens expelled from the west coast. Over 100,000 men, women, and children were moved first to assembly centers, then to relocation camps. There were three assembly centers in our area in Stockton, Merced, and Turlock (at the fairgrounds). Most Turlock Japanese were assembled at the Merced Fairgrounds and taken to the Amache Relocation Center in Colorado (pictured above). (Courtesy Esther Noda Toyoda Collection.)

The war weighed heavily on everyone in Turlock, including students. This was reflected in the 1943 *Alert* where the dedication reads as follows: (Courtesy Turlock High School.)

> *To the students and faculty members of T.U.H.S. who have gone and are going into the armed forces of the United States of America; to the men and women from our school who are marching on to battle to bring this war to a showdown; to those who are leaving us to fight for the ideals we hold as the rights of man, we dedicate this 1943 Alert. To you, who will carry out this colossal and memorable task, we wish the best of luck and God's speed for your safe return.*

Pictured in this photograph are some of the 800 employees of the Chemurgic Plant who produced bombs and flares at the west Turlock facility. In August 1942, Chemurgic, under the leadership of Everett B. Luther, president and E.E. Luther, board chairman, received the Army-Navy "E" Award for efficiency, safety, and record production in war material output. (Courtesy Jim and Gert Hughes Collection.)

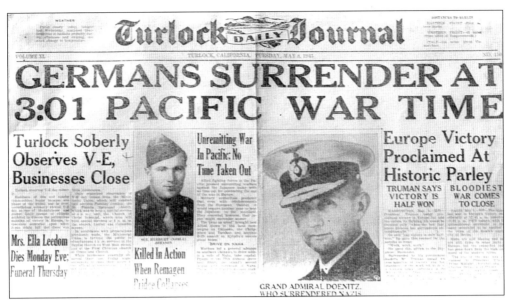

The German surrender meant victory for all in Europe, but the newspaper article about the "unremitting war in the Pacific" reminded readers that their efforts and support had to continue. (Courtesy *Turlock Journal*.)

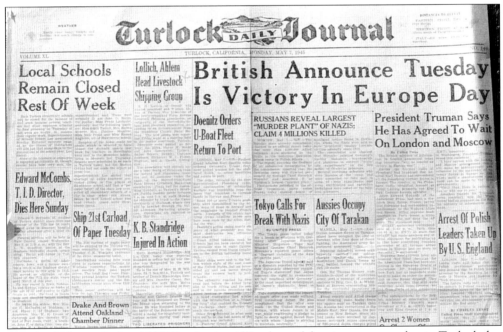

May 8, 1945, was declared V-E Day by the Allies, but celebrations were somber in Turlock due to the death of Roosevelt and the concern for the sacrifices occurring in the South Pacific. (Courtesy *Turlock Journal*.)

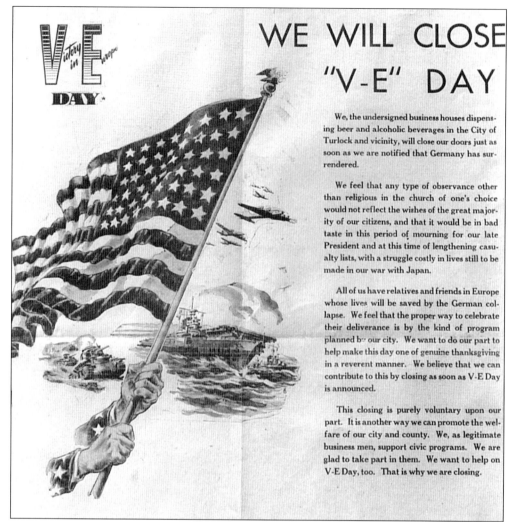

This announcement appeared in the *Turlock Journal*, advising citizens that local liquor-serving businesses would be closed when Germany surrendered. They encouraged people to observe V-E Day by attending church and celebrating in a reverent manner. (Courtesy *Turlock Journal*.)

This text and cartoon was paid for by local businesses and individuals and was printed in the newspaper after V-E Day. (Courtesy *Turlock Journal*.)

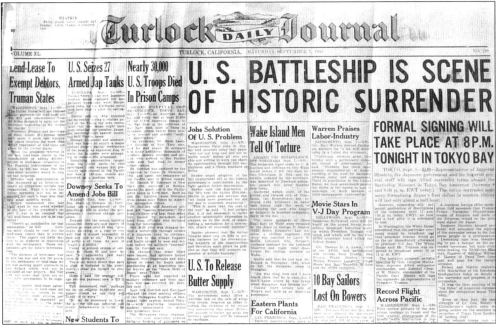

The signing of the Japanese surrender on September 2, 1945, ended World War II. General McArthur signed for the Allies and General Umezu signed for the Japanese. (Courtesy *Turlock Journal*.)

Celebrations took to the streets when President Truman declared September 2nd V-J Day. The café sign, pictured above, represents the way all Americans suspended the normal tasks and rejoiced that the fighting was over. The emotional strain of the war was over as well. One Turlock mother said that she would no longer fear the arrival of a telegram or the daily mail. The sacrifices and efforts on the home front combined with the acts of bravery and ultimate sacrifice in battle had secured victory for the free world.

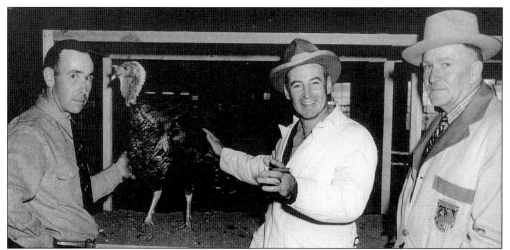

The Far West Turkey Show was formed by Glen Drake and Harry Nystrom in the early 1940s and was sponsored by the Turlock Chamber of Commerce. At the show people in the industry could learn about the latest medicines, turkey feeds, and equipment. Live and dressed turkeys were shown and judged to compare the type and quality of birds. These comparisons prompted industry improvements, such as the development of the broad-breasted turkey. Turlock High School FFA students participated in the event, showing birds and setting up exhibits. In the photo are judges and growers, from left to right, Ray Conyers, Turlock, A.P. Holly, Hemit, and Harvey Griffith, Sonoma, who participated in the boom of the industry in the 1940s and '50s. Conyers, past president of the show and local grower, was involved in the breeding and hatching of top-string turkey eggs that were marketed all over the country. (Courtesy Ray Conyers Collection.)

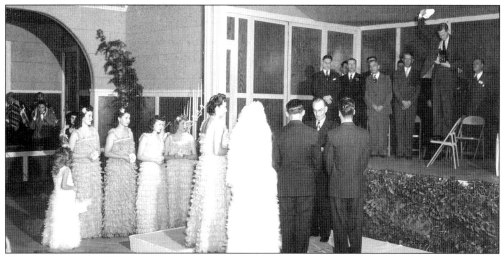

The February 9, 1948, *Life* magazine contained an article entitled "*Life* Goes to a Turkey Wedding." Barbara Orr created and sold hats, costumes and dresses embellished with feathers. She and her fiancé, Fred Ehrhart, wanted to be married at the Far West Turkey Show. The wedding took place at the Turlock Ballroom, the bride wearing a wedding dress of 37,500 white turkey feathers. The four bridesmaids, one of them Beatrice Enos of Turlock, also wore turkey feather dresses. In this photo the *Life* photographer can be spotted capturing the "I do" moment. At the reception a full turkey dinner was served and turkey feathers were thrown instead of rice as the couple departed. (Courtesy Beatrice Enos Hapgood Collection.)

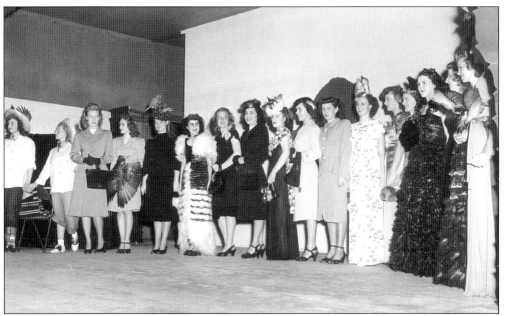

Barbara Orr Ehrhart's creations were featured at a fashion show during the Far West Turkey Show. Local girls modeled the fashions and some of them found their pictures in *Life* magazine in the wedding article. (Courtesy Beatrice Enos Hapgood Collection.)

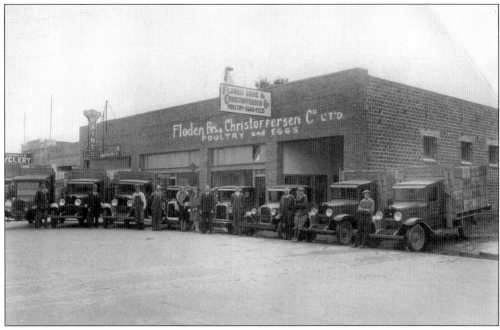

Floden Bros. & Christoffersen Co. (pictured above) was one of Turlock's successful turkey growers and processors. The company experienced the industry growth that began in the early 1940s. The year 1943 saw the invention of the automatic plucking machines and outdoor runways replaced with huge hen houses as flock sizes soared following World War II. (Courtesy Ailene Christoffersen Cross Collection.)

Eight
CITY OF CHURCHES

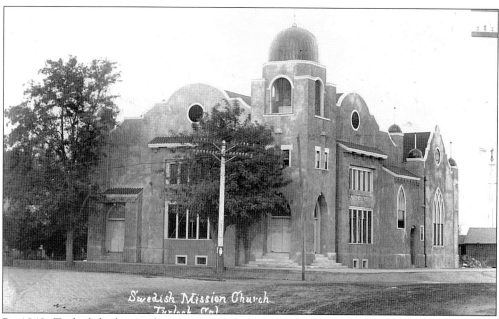

By 1949, Turlock had gained a reputation as a "city of churches." While the origin, lifespan, architecture, and denomination of each institution varied, all churches seemed to serve as a center of commonality, social interaction, and continuity during ever-changing times. The Swedish Mission Church, pictured above, was organized in December 1902. In 1908 a full time pastor, the Reverend E.M. Carlson, was hired and the new church with seating for 600 was completed at Lander and West Main Streets. (Courtesy Mike Ertmoed Collection.)

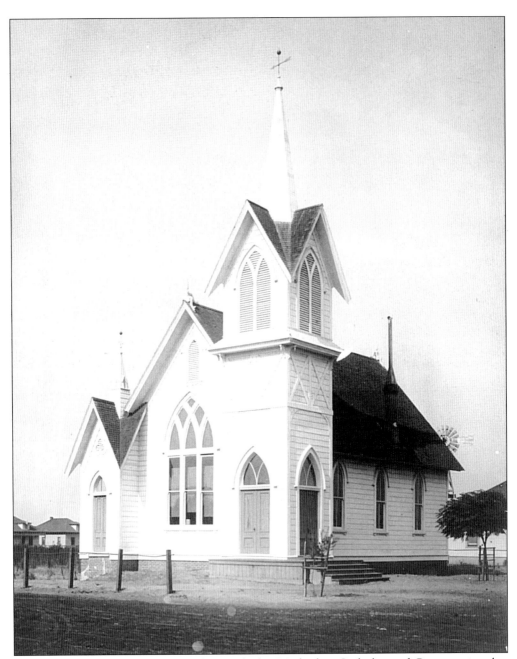

Of the first three churches organized in Turlock—Methodist, Catholic, and Congregational—the Congregational had the shortest lifespan but typified the church establishment process. In 1886 Turlock citizens decided to build a new church. Dances and dime socials were held to raise funds, a contribution was received from the Congregational Board back east and Horace Crane donated land at the corner of Center and Olive Streets. On March 10, 1889, the Congregational Church was dedicated. During a three month run, two lost individuals were converted, but administrative infighting over maintenance and pastoral pay led to the church's demise. Horace Crane bought the land back at a tax sale and later sold it to the Brethren Church in 1902. (Courtesy Mike Ertmoed Collection.)

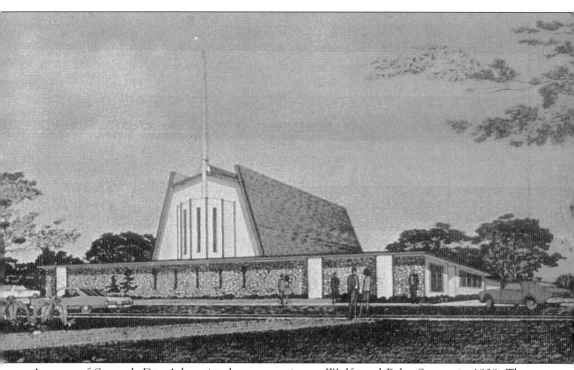

A group of Seventh-Day Adventists began meeting at Wolfe and Palm Streets in 1908. The Turlock Adventist School was founded in 1909 with 40 pupils, and the church moved to Columbia and Orange Streets in 1920. Reflective of Turlock's cultural diversity, services were held in Swedish and English. Portuguese services were added in the 1940s. The current school opened in 1948 at 830 East Minnesota after Dr. Amos Henry donated the property. Services continued at the Columbia and Orange site until 1968 when the North Olive church site (pictured above) was completed. (Courtesy Turlock Historical Society.)

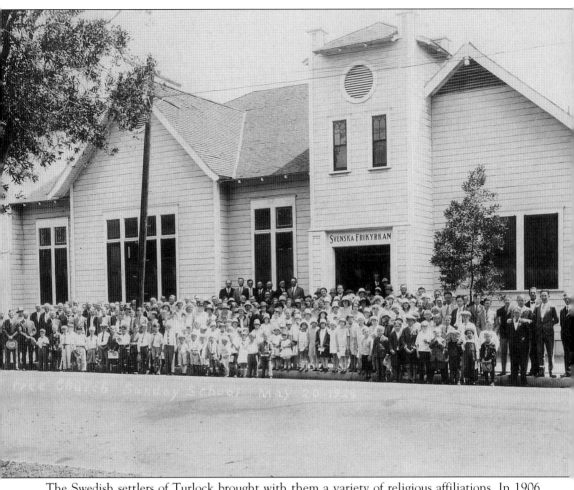

The Swedish settlers of Turlock brought with them a variety of religious affiliations. In 1906 the Nazarene Lutheran Church and the Svenska Frikyrkan (Swedish Free Mission Church) were organized. The latter was also called the Swedish Evangelical Free Church and today is known as the Evangelical Free Church. It was organized in the home of A.G. Bergstrom until a small church was built. In 1915 the annual Evangelical Free Church of America conference was held in Turlock. The 1928 Sunday school classes are pictured above. Membership growth forced expansion of the building five times until a new church was built at Johnson and Arbor Streets. (Courtesy Turlock Historical Society.)

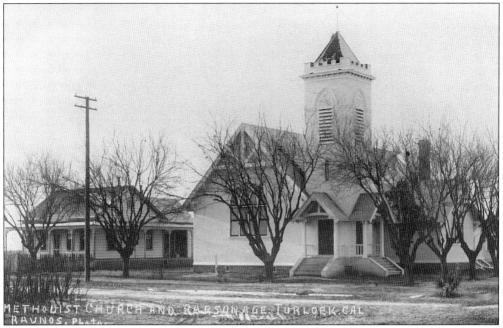

The Methodists were also organized in 1906 and met at the S.V. Porter home. Now called United Methodists, the congregation met at the Gall-Denair building for a time, then at a church on Center Street (pictured above) and later at a church on A Street and South Broadway. In 1953 the church moved to its current home at Arbor and Berkeley. In 1908, the pastor, J.M. Hilbish, made local headlines when he was horsewhipped by three female Palm Restaurant employees. The women were angry over alleged statements by Hilbish suggesting they were disreputable women. (Courtesy Mike Ertmoed Collection.)

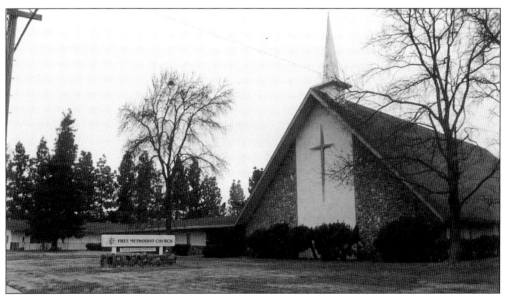

The Turlock Society of the Free Methodist Church met at a private home in Turlock in 1913. They built a permanent structure on North Center Street and Mitchell Avenue where the church remained until 1971, when a new church, pictured above, was built on East Tuolumne.

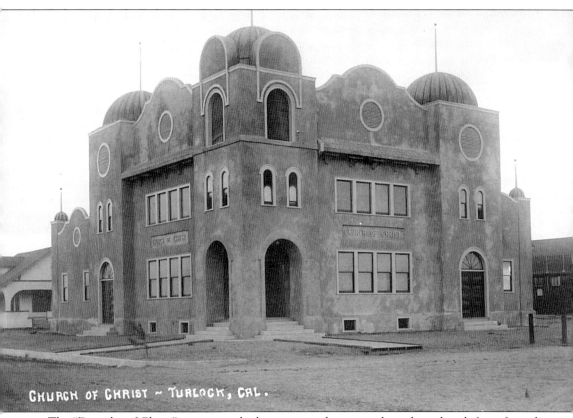

The "Disciples of Christ" movement had its roots in the east and sought a church free of creeds and regulations. Some of these disciples arrived in Turlock in 1906 and established a tabernacle, called Turlock Church of Christ, at East Main between Thor and Palm. In 1911 property was donated by the Crane family at Denair and Crane and the completed Church of Christ, pictured above, hosted a dedication service under the direction of Rev. C.S. Needham. Unfortunately, a fire destroyed the building a few years later and the church moved to its current location on South Denair in 1916. (Courtesy Turlock Historical Society.)

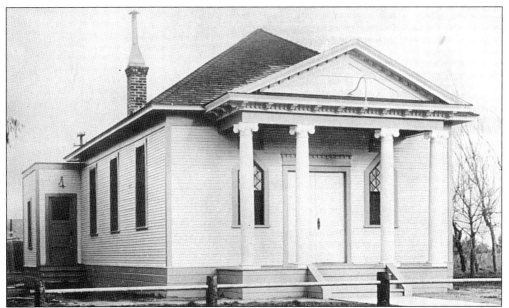

The Baptist denomination appeared in Turlock between 1910 and 1911. Services of the Swedish Baptist Church were first held in the F.O. Nelson home and later in a church built on South Broadway. The church began with 19 charter members and 8 children and all services were conducted in Swedish until 1919. In 1915 the church moved to a building at Locust and Columbia Streets and the name was later changed to Calvary Baptist. During WWII the choir had to disband as members went off to war, but as soldiers returned, the choir resumed in 1947. In 1973 the congregation moved to a new building at Monte Vista and North Olive. (Courtesy Turlock Historical Society.)

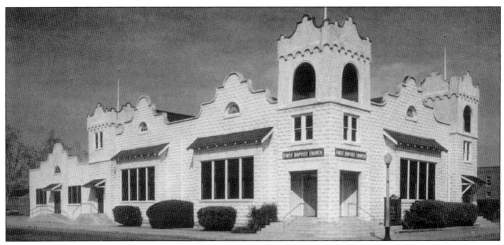

A preacher came from the American Bible Publication Society, and after conducting services and a survey of the town, it was concluded that Turlock could support an English speaking Baptist Church. The First Baptist Church was incorporated in 1909 and met at the Adventist church building until their own was completed in 1910 at A and Third Streets. From 1914 to 1973 the congregation met at their church at West Main and Laurel (pictured above). In 1918, the church was used as a hospital during an influenza epidemic in Turlock. The current home of the First Baptist Church is at West Olive and Laurel Streets. (Courtesy Turlock Historical Society.)

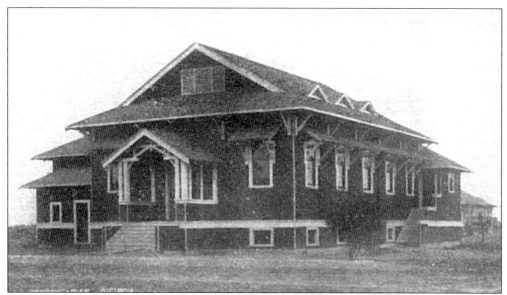

The First Presbyterian Church was organized in 1910. The first pastor was John E. Blair and meetings were held in the Brethren Church and then at Broadway Hall. The congregation then built a church on Crane and Palm Avenues (pictured above). In 1916, the church members voted to consolidate with Turlock Park Presbyterian. (Courtesy Turlock Irrigation District.)

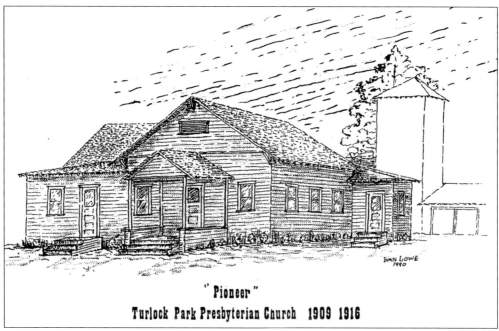

In 1911 the Turlock Park Presbyterian Church was located about five miles west of town at West Main and Faith Home Road. The church, organized in 1909, had formerly been called Pioneer Presbyterian. It was started at Mitchell School by a small citizen group including Homer Pitman (father to John Pitman). When the church merged with First Presbyterian in 1917, the West Main site was sold to William Lowe. His son Ivan lives in the parsonage today and has provided this drawing of the church. (Courtesy Ivan Lowe Collection.)

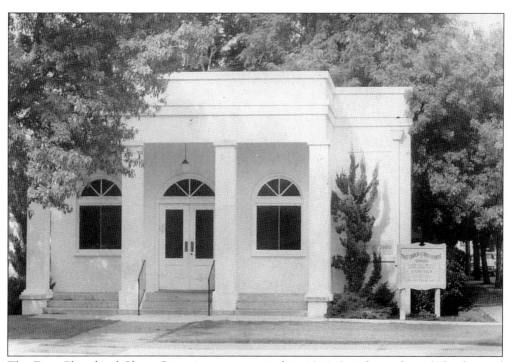

The First Church of Christ Scientist was organized in 1910. It is located on Columbia and Laurel Streets. (Courtesy Turlock Historical Society.)

The rise of the Pentecostal movement occurred in Turlock in the 1920s. Bethel Temple, Assembly of God, was formed by a group from the Evangelical Free Church who wished to follow the Pentecostal beliefs and style of worship. Prayer meetings were held in private homes and then a mission (pictured above) was established in 1917 at A and Third Streets. The present sanctuary was constructed at that same site and today is called Harvest Christian Center. (Courtesy Robert Brown Collection.)

About 1910 Ben F. Rude, Harmon Covey, R. Fanning, and Mrs. McConnell began holding church meetings at their homes. In 1911 worship meetings moved to the old Roselawn school building. Later, the Church of Christ chapel, pictured above, was built on North Tully.

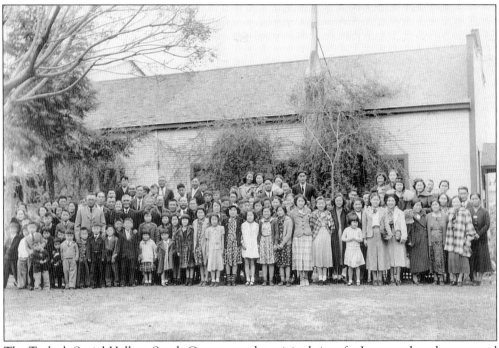

The Turlock Social Hall on South Center was the original site of a Japanese laundry operated from 1912 to 1917. The building served as headquarters for the Central California Cantaloupe Company, the Stanislaus Japanese Association, and the Social Hall. It was also the site of a Japanese School and Buddhist Temple. (Courtesy Esther Noda Toyoda Collection.)

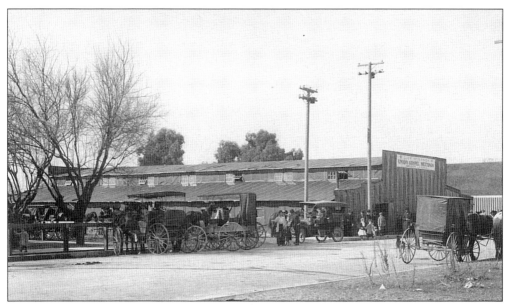

Evangelist Dan Shannon's 1911 Union Gospel Meeting Tabernacle, constructed on Broadway (today's city hall site), brought large numbers to Turlock to hear the word of God. Another evangelist, Aimee Semple McPherson, came to Turlock in 1922. The Turlock Women's Club decorated the Knutsen warehouse on Third Street with cypress, bridal wreath, lilacs, and roses for the meeting. Seats for 2,300 people were arranged and there was standing room for 200 more. A platform was erected for the 300 singers traveling with the evangelist. City officers were appointed to regulate parking as "machines" were not permitted within one-half block of the meeting site. (Courtesy Turlock Historical Society.)

The 1940s marked a second wave of church organization and construction in Turlock. The Free Will Baptist, Eastside Church of Christ, Church of the Good Shepherd, St. Francis Episcopal, Church of the East, West Avenue, and the Church of Latter Day Saints were all established during this time. Pictured above is the Church of Jesus Christ of Latter Day Saints at its present location on Geer Road. The first Turlock Ward members were from the Daniel Anderson family who came to Turlock in 1911 and attended services in Modesto. In 1946 Turlock Ward services were held in the Odd Fellows Hall and in 1954 the first church was built on Berkeley Avenue.

St. Francis Episcopal Church was founded in 1919 by W. Coburn Cook and a group of fellow Episcopalians. They met in a residence, disbanded, and regrouped again in the 1930s. The church received Reverend McMurdo Brown as its first priest and purchased property that had been the TID stable yard at East Main and Pioneer. The church was completed and dedicated in July of 1949.